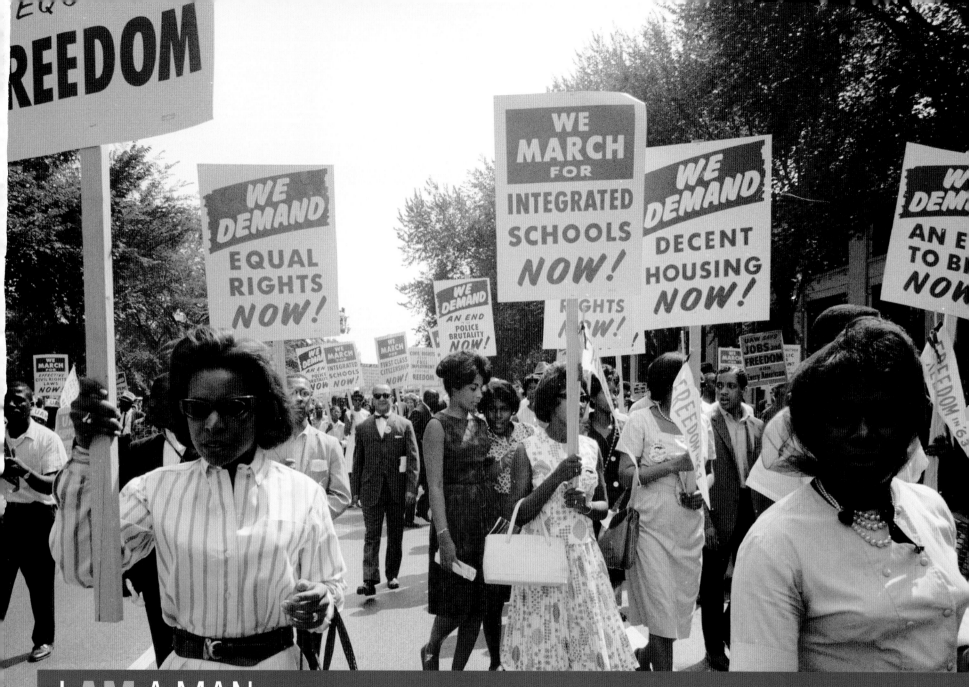

I AM A MAN

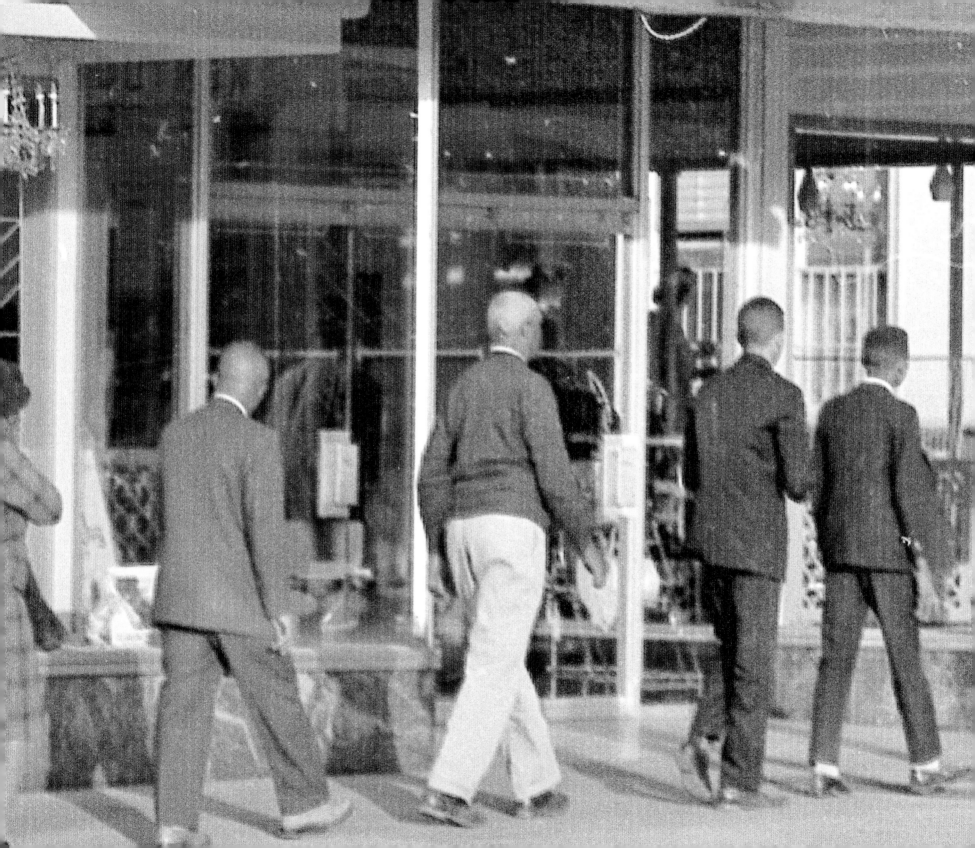

I AM A MAN

Photographs of the Civil Rights Movement, 1960–1970

WILLIAM R. FERRIS Foreword by Lonnie G. Bunch III

University Press of Mississippi / Jackson

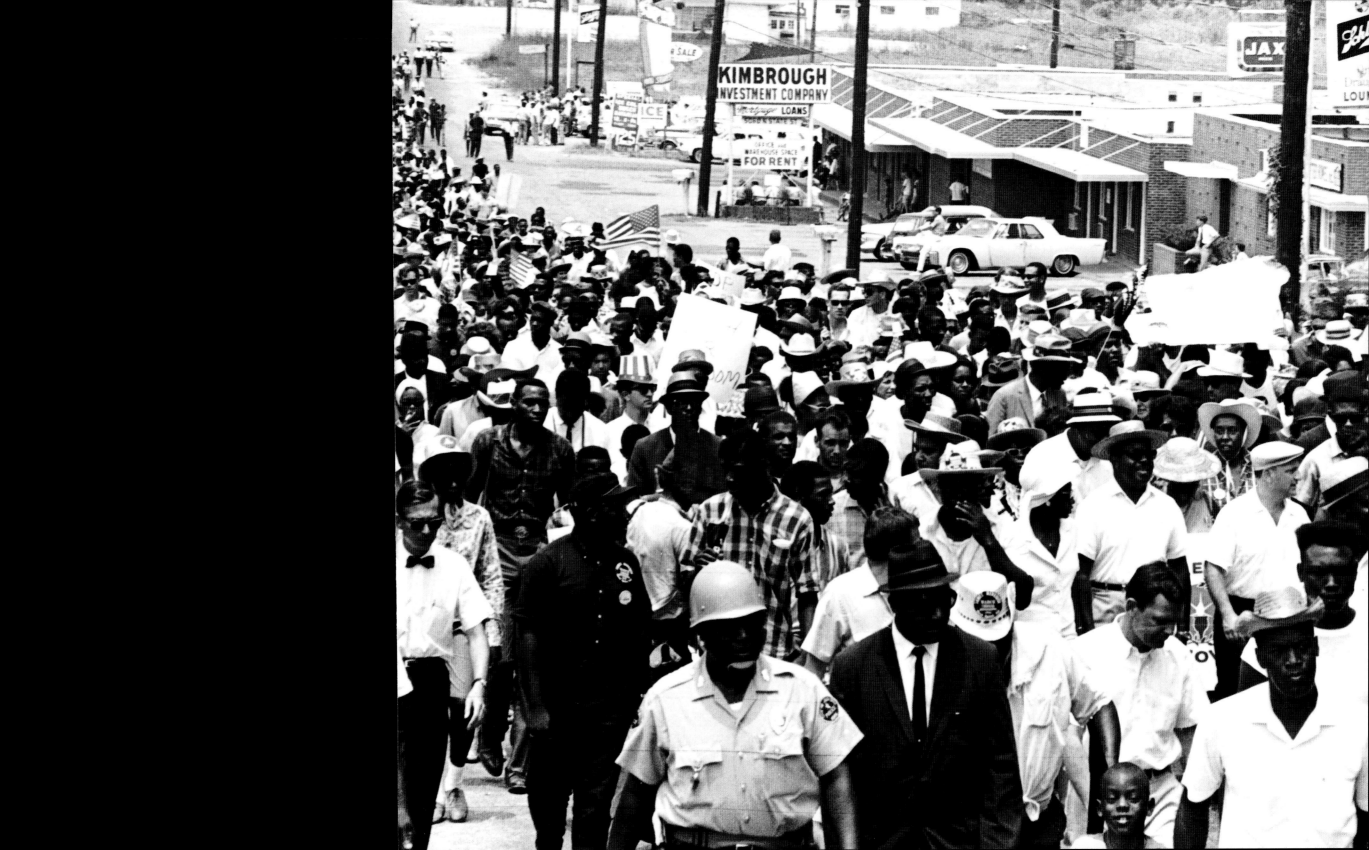

Publication of this book is made possible in part by a generous
donation from the Center for the Study of the American South
at the University of North Carolina at Chapel Hill.

CENTER FOR THE STUDY OF THE
AMERICAN SOUTH

THE UNIVERSITY
of NORTH CAROLINA
at CHAPEL HILL

The University Press of Mississippi is the scholarly publishing
agency of the Mississippi Institutions of Higher Learning:
Alcorn State University, Delta State University, Jackson State
University, Mississippi State University, Mississippi University
for Women, Mississippi Valley State University, University of
Mississippi, and University of Southern Mississippi.

www.upress.state.ms.us

The University Press of Mississippi is a member
of the Association of University Presses.

Originally published in 2018 by Ville de Montpellier and
Éditions Hazan as *I AM A MAN: Photographies et luttes
pour les droits civiques dans le Sud États-Unis, 1960–1970*

First printing 2021
∞

Library of Congress Cataloging-in-Publication Data available

LCCN 2020030522
ISBN 9781496831620 (hardback)
ISBN 9781496831637 (epub single)
ISBN 9781496831644 (epub institutional)
ISBN 9781496831651 (pdf single)
ISBN 9781496831668 (pdf institutional)

British Library Cataloging-in-Publication Data available

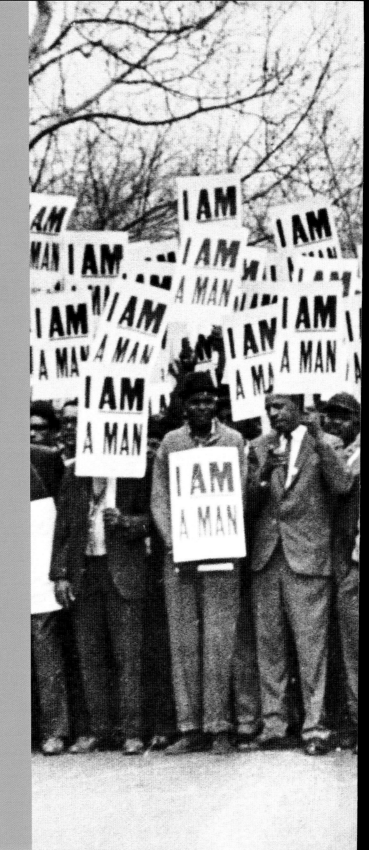

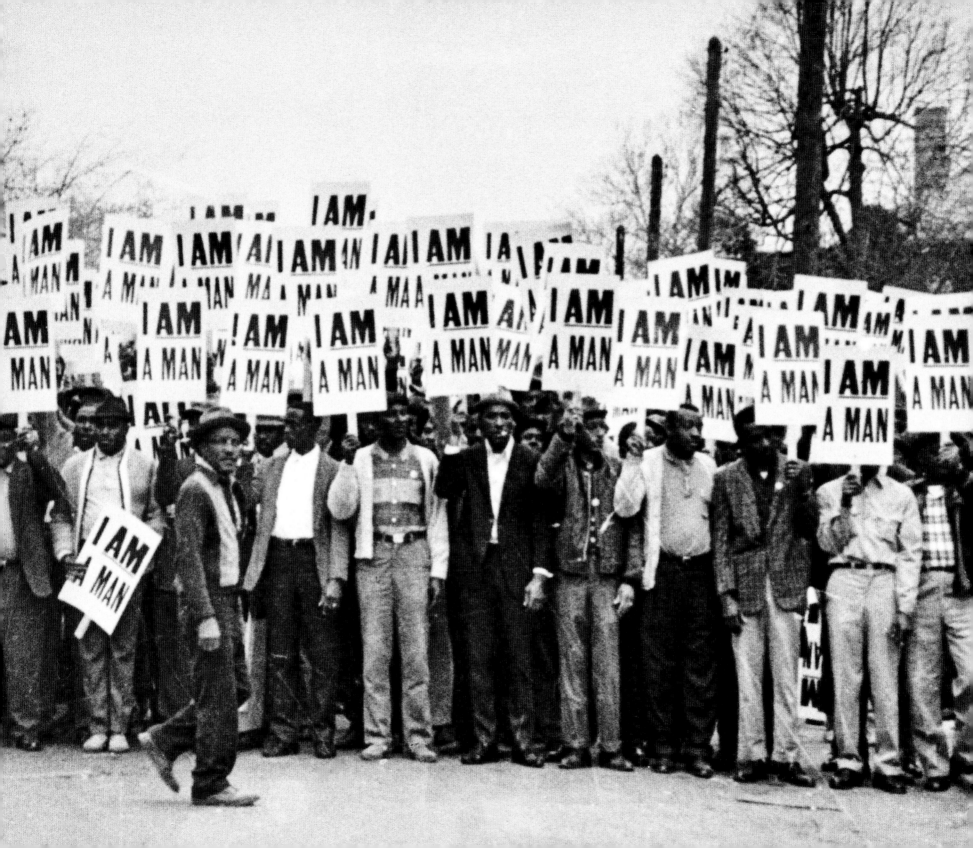

CONTENTS

xi Foreword

xiii Acknowledgments

2 **I AM A MAN**
 Photographs of the Civil Rights Movement, 1960–1970

24 **1961**
 Freedom Rides, Jackson, MS, Birmingham, AL

28 **1962**
 James Meredith Integrates University of Mississippi, Oxford, MS

34 **1963**
 March on Washington

40 **1964**
 Ku Klux Klan Rally in Salisbury, NC

60 **1965**
 Selma to Montgomery March

76 **1966**
 James Meredith March Against Fear, Jackson, MS

84 **1968**
 Mule Train–Poor People's March on Washington, Marks, MS

90 **1968**
 Sanitation Workers Strike, Memphis, TN

94 **1968**
 Martin Luther King Jr. Assassination, Memphis, TN

112 **1970**
 Jackson State University

119 Photographer Biographies

123 List of Reproduced Photographs

FOREWORD

During the summer of 1964, my family traveled from our home in New Jersey to a small town in rural North Carolina to visit my maternal grandparents. Though the interstate highway system was under construction, most of the trip took us on two-lane roads through small southern towns that were scenic, historic, and segregated. As with any African American family journeying down south in Jim Crow America, we prepared to face the reality of restaurants that did not cater to all who hungered, billboards that celebrated the local presence of the Ku Klux Klan, and police officers whose enforcement of the law was shaped or misshaped by the color line.

I remember vacillating from being vigilant in case of trouble to napping to help pass the long hours on the road. Shortly after midnight I was awakened as the car stopped and my father, then the sole driver in the family, needed a break. He had pulled off the road and into a motel/ motor lodge that was comprised of a semicircle of individual cabins. When I looked up, he was having a cigarette under a sign that read "Whites Only." I was scared, worrying that we would run afoul of the discrimination and the often violent response that was an everyday part of life for black Americans. He stood under that sign for what seemed an eternity. When he finally returned to the car, he sensed my fear and anxiety. He looked at me and said, "Don't worry,

this is my America too. I fought in a war and I am a citizen and no one can tell me where I can stand as I breathe the air." While I was still scared, I was also proud of my father's small but important victory in the struggle to make a fairer and freer America.

I had not thought of that moment for many years until I examined the amazing, powerful, and poignant images that comprise *I AM A MAN: Photographs of the Civil Rights Movement, 1960–1970*. These images remind us of not just the powerful moments like the Ernest Withers shots of Martin Luther King Jr. or the way Spider Martin captured the bravery and the carnage of "Bloody Sunday" in Selma, Alabama, but also the less remembered, smaller acts of bravery and resistance like my dad quietly confronting segregation or the image of the dignified African American woman in the "paddy-wagon" in Birmingham by Bob Adelman. This collection helps us realize how significant actions and more modest, often unacknowledged victories helped to transform a nation.

Early in my career, I sought to understand how slavery and segregation shaped and continued to shape this nation. During my research I was introduced to a ninety-year-old sharecropper named Princy Jenkins who lived his whole life working the rice fields outside of Georgetown, South Carolina. After spending time with Mr. Jenkins,

he wanted to know what I did. As I explained the work of a historian, he said, "I hope you help people remember not just what they want to remember but what they need to remember." That is what this collection of photography does so well. It helps us to remember.

To me, this collection captures such a crucial decade in American history and helps us to remember an unvarnished history with clarity and candor that would make Mr. Jenkins proud. In the years since the active struggles of the 1960s, a rosy glow of nostalgia has softened the rough edges, the hard battles and dimmed our memories about the losses and the violence that accompanied this war for the soul of America. To many, the civil rights movement has morphed into a feel-good moment where America banded together to counter the Ku Klux Klan and other extremists, a battle that revealed America at its best, living up to America's stated ideals. While much of that is true, it also lessens the nation's culpability. Though the civil rights movement eventually drew support that crossed racial and regional lines, and southern blacks found important white allies that enriched the movement, the appeal was not universal. Many Americans worried about the substance and the pace of change. A poll taken in 1967 found that nearly two thirds of Americans opposed or disagreed with the methods of Dr. King. And while images like those taken by Don Sturkey of the Klan captured the concrete manifestations of racism and personal hatred that undergirded white supremacy, many others who would never wear the robes of the Ku Klux Klan actively opposed the racial, legal, and economic changes that were at the heart of the civil rights movement or did little to aid the struggle for a freer America.

These images remind us that fundamental racial change in America was not without loss, courage, or sacrifice. And that the hard-won rights for so many Americans that were an outgrowth of the civil rights movement should never be undervalued or taken for granted. Ultimately, the works included in *I AM A MAN: Photographs of the Civil Rights Movement, 1960–1970* should inspire all who view them to recommit to completing the unfinished tasks of the civil rights movement. And to honor all those whose names have been forgotten and who sacrificed to make a country better. After all, there is nothing more powerful than a people, than a nation steeped in its history, and there are few things as noble as honoring our ancestors by remembering. Thankfully, with collections such as *I AM A MAN*, we will never forget.

—LONNIE G. BUNCH III,
Founding Director, National Museum of
African American History and Culture
Secretary, Smithsonian Institution

ACKNOWLEDGMENTS

This book accompanies *I AM A MAN: Photographs of the Civil Rights Movement, 1960–1970*, a major exhibition presented by the Mississippi Civil Rights Museum. A traveling version of the exhibit will be circulated around the nation by the Mid-America Arts Alliance. The following organizations and individuals are gratefully acknowledged for their contributions to the project.

University Press of Mississippi
Craig Gill, Director
Carlton McGrone, Assistant to the Director
Valerie Jones, Project Editor
Todd Lape, Production and Design Manager
Steve Yates, Associate Director/Marketing Director

Mississippi Civil Rights Museum, Mississippi Department of Archives and History
Katie Blount, Director, MDAH
Cindy Gardner, Two Mississippi Museums Administrator

Mid-American Arts Alliance
Kathy Dowell, Director of Arts and Humanities Programming

Acknowledgments included in the original French edition

This work accompanies the exhibition *I Am a Man: Photographs of the Struggle for Civil Rights in the South of the United States, 1960–1970*, organized by the Pavillon Populaire, a museum of art photography in the City of Montpellier, featured October 16, 2018, through January 6, 2019.

This exhibit was made possible through the generous support of the following:
Philippe Saurel, Mayor of the City of Montpellier and President of the Montpellier Mediterranean Region
Isabelle Marsala, Assistant to the Mayor and Cultural Representative
William Ferris, Curator of the Exhibition
Gilles Mora, Artistic Director of the Pavillon Populaire

General Administration for the City of Montpellier
Christian Fina, General Director of Services
Fabrice Manuel, Adjunct Director of Culture, Sports, Young People, and the Zoo
Jean-Louis Sautreau, Director of Culture and Heritage

General Coordination for the City of Montpellier

Julien Prade, Head of Art and History Institutions

Natacha Filiol, Head of Production for Exhibitions at the
 Pavillon Populaire

Stéphane Ficara, Chief Registrar, with Grégory Macaux and
 David Monny, Registrars

Yves Kempf, Coordinator of Security

Gérard Milési, Head of Human Services

Supporters of the Exhibition and Catalogue

Florence Girard, Graphic Designer

Véronique Senez-Traquandi, Lighting and Sound Design

Christophe Guibert, Valentin Benet, and Catherine Noden, Lighting

Catherine and Prune Philippot, Press Attaches

Jérôme Gille, Director of Éditions Hazan

Pauline Garrone, Editorial Coordinator, with assistance from
 Marion Lacroix

Nicolas Hubert, Graphics

Lola Duclos, Translator

Claire Hostalier, Pierre Hamard, and Ana Cristina Lopes, Fabricators

William Ferris wishes to thank the following people:

Assistant Curators

Matthew LaBarbera

Michaela O'Brien

Advisors

Karida Brown

Christóbal Clemente

Tony Decaneas

Bobby Donaldson

Lester Fant

Ben Fernandez

Erik Gellman

Tommy Giles

Sheffield Hale

Joe et Embry Howell

Janet Kagan

Jim et Barbara Kalas

Randall Kenan

Ed King

Mary King

Edgar Moss

Genna Rae McNeil

Wilfried Raussert

Alan Rothschild

Connor Scanlon

Ann Stewart

Louise Toppin

Burk Uzzle

Lyneise Williams

Photography Representatives

Erica DeGlopper (Art Shay)

Elizabeth Koehn et Tom Brewer (Danny Lyon)

Tracy Martin (Spider Martin)

Dianne Nilsen (Dan Budnik)

Cheryl Shelton-Roberts (Bruce Roberts)

Stephen Watt (Bob Adelman)

Roz Withers (Ernest Withers)

Pavillon Populaire de Montpellier

Natacha Filiol

Gilles Mora

Les Éditions Hazan

Pauline Garrone

Jérôme Gille

Alabama Department of Archives and History

Meredith McDonough

Auburn University

Bruce Kuerten

Duke University

Tom Rankin

Emory University

Randall Burkett

Library of Congress

Beverly Brannan

Mississippi Department of Archives and History

Katie Blount

Eliza Causey

Julie Dees

National Archives and Records Administration

David Ferriero

Smithsonian Institution

Lonnie Bunch

Richard Kurin

Austin Matthews

Myriam Springuel

University of North Carolina—Ackland Museum

Elizabeth Manekin

Peter Nisbet

Katie Ziglar

University of North Carolina—Center for the Study of the American South

Emma Calabrese

Barb Call

Ayse Erginer

Patrick Horn

Terri Lorant

Malinda Maynor Lowery

Rachel Seidman

Emily Wallace

Sara Wood

University of North Carolina—Office of University Counsel

Elizabeth Josephs

Brenda Thissen

University of North Carolina Photo Search Team

Elijah Heyward

Abigail Lee

Virginia Thomas

Greer Underwood

Jay and Stacy Underwood

Mary Williams

University of North Carolina—Wilson Library

Maria Estorino

Stephen Fletcher

Bryan Giemza

Douglas Hollingsworth

Jay Mangum

Chaitra Powell

Aaron Smithers

Matt Turi

Steve Weiss

University of Southern Mississippi

Leah Rials

University of Texas at Austin—Dolph Briscoe Center for American History

Don Carleton

Aryn Glazier

Kendall Newton

William Ferris wishes to thank the following institutions:

Alabama Department of Archives and History

Emory University, Stuart A. Rose Manuscript, Archives, and Rare Book Library

Getty Images

Library of Congress

Lincolnville Museum and Cultural Center

Mississippi Department of Archives and History, Archives and Records Services Division (Sovereignty Commission et Moncrief Collection)

Montgomery County Archives

National Archives and Records Administration

National Film Preservation Foundation

Smithsonian Folkways Recordings

Smithsonian Institution, Division of Political History, National Museum of American History

Smithsonian National Museum of African American History and Culture

Student Nonviolent Coordinating Committee

University of Kentucky Archives

University of North Carolina at Chapel Hill, Louis Round Wilson Special Collections Library (Lew Powell Memorabilia Collection, North Carolina Collections, and Don Sturkey Photographic Materials, North Carolina Collections)

University of South Carolina, Moving Image Research Collections

Virginia Commonwealth University Libraries, Special Collections and Archives

I AM A MAN

I AM A MAN

Photographs of the Civil Rights Movement, 1960–1970

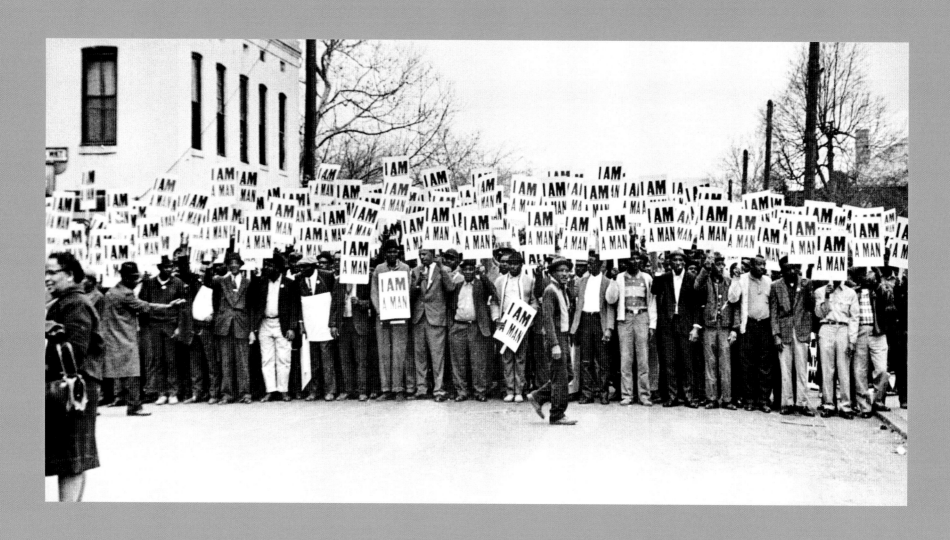

Photographs in this exhibit, like the fabled songs and stories of the American South, bear witness to the region's past, to its people, and to the places that shaped their lives. They are vessels of truth that capture the courage of protestors who faced unimaginable violence and brutality, the quiet determination of elders, and the angry commitment of the young.

These photographs became a wedge in the segregated South during the decade from 1960 to 1970. They document a historic period that unleashed hope for the future and profound change as public spaces were desegregated and blacks secured the vote. The photographs are also a significant backdrop for the transformative Black Lives Matter movement in America today.

We remember photographs of protestors who carried signs with messages like "I AM A MAN" and sat at segregated lunch counters as iconic, familiar images associated with the civil rights movement. Civil rights organizations recognized the power of photography to publicize their efforts and to secure support for their movement. The Student Nonviolent Coordinating Committee (SNCC) hired photographer Danny Lyons to document their struggle. His photographs dramatically illustrated the movement's ideology, as seen in his visceral images of posters held aloft by protestors stating, "Come Let Us Build A New World Together" and "One Man, One Vote."

Lyons recalled how his arrival in Jackson, Mississippi, reminded him of traveling to South Africa. "When the DC-8 landed in Jackson, I might as well have been stepping off in Johannesburg. Everything frightened me. I was supposed to take a colored cab into a colored neighborhood, but it was illegal for black drivers to carry white passengers. And, needless to say, I couldn't ask a white driver to take me to look for civil rights workers. Eventually, I persuaded some brave black driver to take me to the address I had been given for the Freedom House, the occupants of which told me I was at the wrong address. The Freedom House was next door."[1]

Just as black and white protestors joined arms to march and sit in, the photographers were *also* black and white. These photographers covered local communities like Chapel Hill, Memphis, and Jackson for local newspapers that featured their work.

Jim Wallace was a student at the University of North Carolina at Chapel Hill when he photographed demonstrations for the student newspaper the *Daily Tar Heel.* He recalled that a colleague described the secret to photojournalism as, "'f/11, and be there.' . . . I needed to get there just after they started a sit-in and before they were arrested. . . . They needed me to be there to take photographs. My presence helped keep things cool. . . . It took several police officers to carry them out of where they were sitting-in. The entire time they were always singing 'Freedom Songs.'"[2]

Photographs of the American civil rights movement are visual monuments that stand the test of time, and this exhibit affirms that these monuments will never be forgotten. They are a powerful reminder that the past is never past, that lessons learned in one period—the decade of 1960–1970—help us move forward in the global struggle for justice today.

Look at the faces and their expressions as they register to vote, as they desegregate a lunch counter, as they march. The viewer feels their intense sense of conviction, their courage, and invincibility. They are part of the long quest for racial justice that dates from 1619 to the present.

Nineteenth-century abolitionist and antislavery writer Frederick Douglass recognized the importance of photographs for black people who sought freedom and full citizenship as Americans. The most photographed American in his era, Douglass lectured on how black lives are honored and preserved through photographs in his "Lecture on Pictures," "Life Pictures," "Age of Pictures," and "Pictures and Progress." The first photograph of Douglass was a daguerreotype, and he sat for 160 photographic portraits during his lifetime.

In his lecture on "Pictures," Douglass argued that the "great discoverer of modern times, to whom coming generations will award special homage, will be Daguerre. . . . What was once the special and exclusive luxury of the rich and great is now the privilege of all.

Sanitation workers assemble in front of Clayborn Temple for a solidarity march. "I Am A Man" was the theme for Community On the Move for Equality (C.O.M.E.). Memphis, Tennessee, 1968.

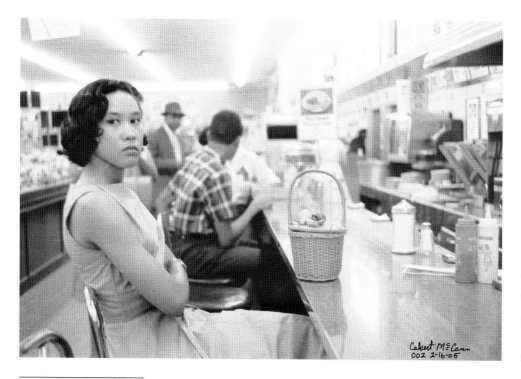

University of Kentucky student Nieta Dunn sitting in the all-white section at a dime store lunch counter, Lexington, Kentucky, 1960.

by Thompson Funeral Home in Port Gibson, Mississippi. Under the title, "Black Leadership During the American Reconstruction," the text notes that, "Following the [Civil] War, Douglass urged the government to protect the rights of the newly enfranchised freedmen, conducted 'freedom rides' and 'sit-ins' in New England against racial discrimination on street cars." The fan clearly connects Douglass with the civil rights movement in the American South.[5]

Photographs of Douglass and other black leaders appear in twentieth-century fiction by black writers like Randall Kenan. Kenan makes extensive use of photography in his short story collection *Let the Dead Bury Their Dead*. In "This Far," a photograph of Booker T. Washington inspires a reflection on Washington and his relationship to black liberation. The photograph was "taken by Frances Benjamin Johnston in 1906: those light eyes, the arched eyebrow, the full nose, the prominent elfin ears, the Indian lips—the word 'handsome' is impeached by 'integrity.' . . . Look at the dark flesh under the eyes—here's a man who's spent many a sleepless night poring over documents and papers to make men free!"[6]

Photographer Art Shay documented James Meredith, the first black student to enroll at the all-white University of Mississippi. He photographed Meredith and the three thousand troops sent by President John Kennedy to protect him. Shay recalls how, "Cameras at the ready, I found myself covering a home-grown war in which, to my horror, I saw the enemy as people like me . . . who thought the whiteness of their skin gave them a better birthright to America than the dark people had. . . . It became the job of photojournalists like me . . . to report what was happening as we watched."[7]

Within the history of photography, images of the civil rights movement mark a distinct body of work. Many of the photographs in this exhibit were taken in the midst of violent, dangerous confrontations between local whites and civil rights workers who risked their lives to engage in nonviolent civil disobedience. Inspired by the voice of Reverend Martin Luther King Jr., thousands of courageous people risked their lives to end Jim Crow segregation within the American South.

The humblest servant girl may now possess a picture of herself such as the wealth of kings could not purchase fifty years ago." Douglass believed that the daguerreotype dignified former enslaved people as the fully realized human beings they were.

Douglas identified photography with freedom, and he "defined himself as a free man and citizen as much through his portraits as his words. . . . His own freedom had coincided with the birth of photography, and he became one of its greatest boosters."[3]

In Douglass's only work of fiction, *The Heroic Slave* (1853), the black hero, Madison Washington, is "daguerrotyped on" the "memory" of his friend and white protagonist, Mr. Listwell. In her novel *Uncle Tom's Cabin* abolitionist writer Harriet Beecher Stowe "daguerotype[s]" her hero Uncle Tom "for our readers."[4]

In the twentieth century, Douglass's photograph appears on black church fans throughout the South, one of which was circulated

As a student during the sixties, I deeply identified with the civil rights movement and the photographs that brought these events into the homes of Americans. My own work as a folklorist, who documented black and white worlds in the South, was shaped and inspired by these photographs and their power.

Who could not be touched by the sight of people attacked simply because they wished to vote, to eat, to study in a public facility? These photographs forced the viewer to decide whether they were with or against the change that was unstoppable. They were a catalyst for moving history forward, and they challenged daily lives at the grass-roots level.

It is said that when Abraham Lincoln met Harriet Beecher Stowe in 1862, he remarked, "So you're the little woman who wrote the book that made this great war!" Just as Stowe's novel *Uncle Tom's Cabin* stirred outrage against slavery, these photographs inspired support for the civil rights movement around the world. Images of neatly dressed, college-age demonstrators tear gassed and beaten on the Edmund Pettus Bridge in Selma, Alabama, taken by Spider Martin; of an effigy of James Meredith hung from a rope at the University of Mississippi taken by Art Shay; and the body of Reverend Martin Luther King Jr. as it lay in state in Memphis taken by Ernest Withers galvanized opposition to Jim Crow apartheid in the American South.

Ernest Withers's photographs of demonstrators holding "I AM A MAN" signs affirm that black lives truly *do* matter. These images pull back the veil of invisibility and reveal the humanity of black men, women, and children who voted, marched, and sang freedom songs to affirm their full citizenship as Americans almost sixty years ago.

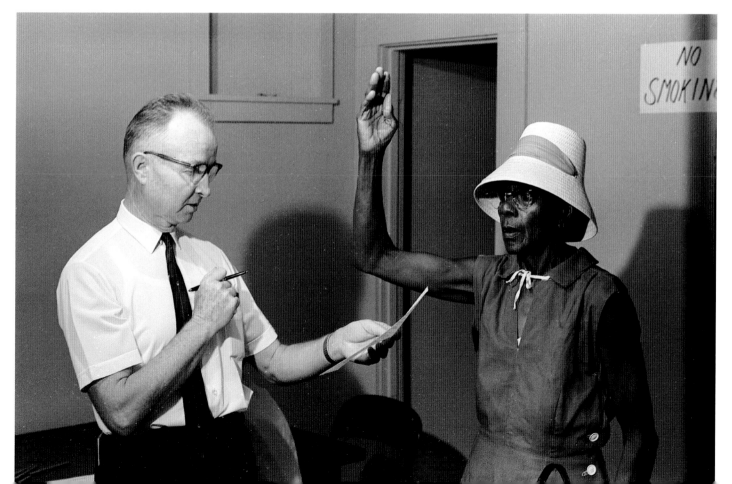

Voter registration August 25, 1965; federal examiner C. A. Phillips administers voter registration oath to Joe Ella Moore, Prentiss. Mississippi.

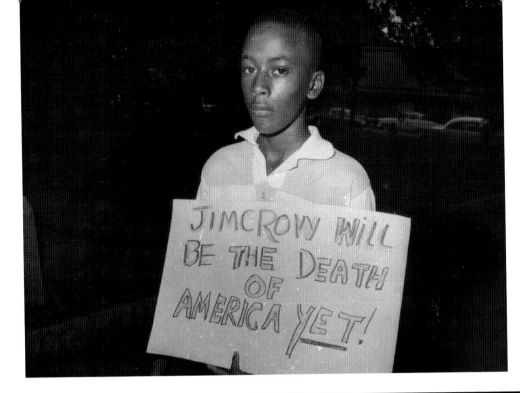

While photographing the funeral of Medgar Evers in Jackson, Mississippi, in 1963, Ernest Withers recalled, "I was standing on the sidewalk taking one horrible scene after the other amid the screams. Suddenly a burly white man . . . came over and snatched me into the street. The force of the movement took the top off of my camera. As I tried to retrieve it, a policeman came over and began beating me with a nightstick and ushering me toward the truck.[8]

Music was a powerful force for organizing demonstrators with freedom songs such as those sung by Bernice Johnson Reagon and the SNCC Freedom Singers. Legendary singers like Sam Cook, the Staple Singers, Pete Seeger, and Bob Dylan sang at civil rights events. Reverend Martin Luther King Jr. had a special love for Mahalia Jackson's gospel music, and she inspired his "I Have a Dream" speech at the Lincoln Memorial when she told him, "Tell them about the dream, Martin! Tell them about the dream!"

Protester with sign reading "Jim Crow Will Be the Death of America Yet!" Farmville, Virginia, 1963.

Singer Mahalia Jackson at the Charlotte Coliseum, November 21, 1961. Charlotte, North Carolina.

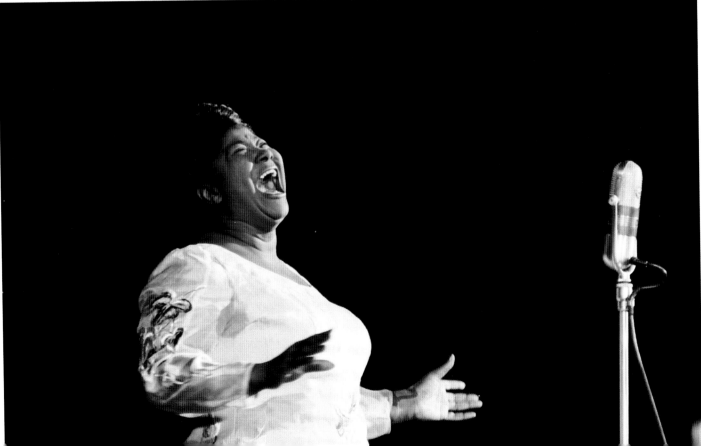

The anthem of the civil rights movement, "We Shall Overcome," was adapted from a traditional black spiritual by Pete Seeger. Seeger explained how he "changed the 'will' to 'shall' . . . I think it opens up the mouth better. . . . Within one month, it spread through the South. It was the favorite song at the founding convention of SNCC three weeks later in April 1960 in Raleigh, North Carolina, where people came from all through the South. . . . In Selma, Alabama, a lot of people were singing it because they wanted to overcome Sheriff Jim Clark, who was beating people up and throwing them in jail."[9]

Photographers who grew up in the South were well aware of the danger they faced when they approached demonstrators and police. Charles Moore, a Florida native, recalled how, "As a born and bred Southerner, I was often shocked at the behavior of some people in places like Selma, Birmingham, Oxford, and St. Augustine. Their faces, contorted in anger, threatened me and cursed at me. I was not the instigator of violence; I was there to record news events that were making history. For all journalists covering the civil rights story through the sixties, it was difficult, exhausting, and often very dangerous. For me, it was all the above plus troubling and emotional in a personal way because I am a Southerner, too."[10]

Spider Martin, a native of Fairfield, Alabama, was familiar with racial views prevalent in his state. As he photographed near the Brown Chapel AME Church in Selma, Alabama, Martin recalled, "These Alabama state troopers are looking at me. I thought they were going to shoot me. They had been told by Gov. Wallace that Spider Martin has had too many pictures in the Yankee Press. 'Get him.' . . . A lady grabbed me by the arm and pulled me inside her apartment. She said get yourself in here before they kill you. All of a sudden I was inside and smelled soul food. She said sit down and eat. I had turnip greens, black eyed peas, pork chops, corn bread, and iced tea. I woofed it down and started to leave, but she said I should eat the banana pudding. I said I had to go, but looked out and saw that Dallas County posse deputy with that big gun. I ate the banana pudding."[11]

After Martin photographed a civil rights marcher wearing a jacket with "Alabama God Damn" written on its back, he spoke with the marcher and asked him, "what Alabama goddamn meant. He said it meant, 'Lord, these people have enslaved my people for 400 years, damn them.'"[12]

Black Americans have associated photography with freedom for over 150 years, and the images in this exhibit resonate with special power. Just as the photograph of "Whipped Peter" Gordon, a former enslaved laborer whose back was scarred by a whipping he received in 1863 on the Lyons plantation in Louisiana, and just as the 1955 photograph of Emmett Till's mangled face that his mother Mamie Till insisted be displayed in its open casket to let "the world see what they did to my boy" are seared into our memory, these images bear witness to the violence faced by courageous protestors. The memory of that violence was rekindled as we witnessed scenes of violence and murder in the "Unite the Right" rally in Charlottesville, Virginia, in August 2017.

The 1955 photograph of Emmett Till was a searing image that inspired the civil rights movement that followed during the sixties, when photographs in this exhibition were taken. These photographs document the sit-ins in Greensboro, North Carolina, in 1960, the Freedom Riders in 1961, voter registration drives, the admission of James Meredith as the first black student to enter the University of Mississippi in 1963, the March on Washington in 1963, the Freedom Summer of 1964, the murder of Reverend Martin Luther King Jr. in Memphis in 1968, and the killing of Phillip Gibbs and James Green at Jackson State University in 1970.

To paraphrase Mamie Till, these photographs remind us of "what they done to our people—black, white, old, young, Protestant, Catholic, and Jew, all of whom marched for freedom." Thirty percent of the Freedom Riders were Jewish, many of whom were children of Holocaust survivors. Two of these children—Andrew Goodman and Mickey Schwerner—and their fellow civil rights worker James Chaney

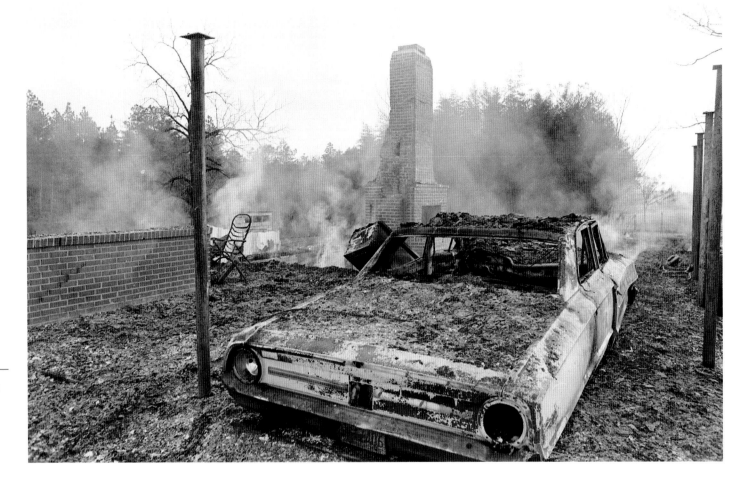

Charred remains of Vernon Dahmer's car the morning his house and store in the Kelly Settlement were firebombed on January 10, 1966.

were murdered near Philadelphia, Mississippi, during Freedom Summer in 1964. We remember their photographs as they appeared on an FBI missing persons poster in 1964.

The Ku Klux Klan used terrorist violence to intimidate civil rights workers and black families. Memorable examples of such violence include the 16th Street Baptist Church bombing in Birmingham, Alabama, on September 15, 1965, when fifteen sticks of dynamite planted by four members of the Klan exploded and killed four young girls and injured twenty-two others. Reverend Martin Luther King described the event as "one of the most vicious and tragic crimes ever perpetrated against humanity."[13]

The Klan struck again on January 10, 1966, when they fire-bombed the home of Vernon Dahmer, a prominent black businessman and

former president of the Forrest County Chapter of the National Association for the Advancement of Colored People (NAACP) in Hattiesburg, Mississippi. As he helped his wife and children escape their blazing home, Dahmer was severely burned and later died of smoke inhalation. Photographs of both the bombed church in Birmingham and the burned home in Hattiesburg are lasting reminders of the price innocent people paid in their struggle for civil rights.

The decade of 1960–1970 tragically ended in Jackson, Mississippi, on the campus of Jackson State University, where two students, Phillip Lafayette Gibbs, a junior at Jackson State, and James Earl Green, a senior at Jim Hill High School, were killed, and twelve other students were wounded by Jackson police on May 14, 1970. Photographer Doris Derby worked at Jackson State at the Margaret Walker Center

and also taught in the Art Department at the time of the shooting. Derby was also on the staff of SNCC's Poor People's Corporation and Southern Media Inc., a documentary photography and filmmaking unit. She photographed the funeral procession for Gibbs and Green as it passed Alexander Hall, where the shooting occurred.

Derby recalled that, as the hearse drove by, students with raised fists "were guarding the building because they did not want officials to clean the crime scene. They were waiting for the FBI to examine the evidence. They had laid wreaths of flowers in memory of the two students killed and the twelve students injured."[14] Derby also photographed Mayor Charles Evers, Congressman Adam Clayton Powell Jr., and Congressman Edward W. Brooke III, when they met in Jackson with the President's Commission on Campus Unrest to investigate the shootings.

The sixties were a momentous time for the civil rights movement in the American South and in the nation. Photographs in *I AM A MAN* are a reminder to us today and to future generations that we must continue the fight for justice for all humankind.

—WILLIAM FERRIS
University of North Carolina at Chapel Hill

NOTES

1. Danny Lyon, *Memories of the Southern Civil Rights Movement* (Chapel Hill, NC: University of North Carolina Press, 1992), p. 38.

2. Jim Wallace, *Courage in the Movement: The Civil Rights Struggle, 1961–1964* (Mineola, NY: Dover Publications, 2012), pp. xvii, 20–21.

3. John Stauffer, Zoe Trodd, and Celeste-Marie Bernier, *Picturing Frederick Douglass: An Illustrated Biography of the Nineteenth Century's Most Photographed American* (New York: Liveright Publishing Corporation), p. xi.

4. Frederick Douglass, *The Heroic Slave* (Boston: John P. Jewett, 1853), p. 45, and Harriet Beecher Stowe, *Uncle Tom's Cabin* (Boston: John P. Jewett, 1852), p. 68, both cited in Gregory Fried, *"True Pictures": Frederick Douglass on the Promise of Photography* (Boston: Suffolk University), http://nathanielthurner.com/douglassprogressphotography.htm.

5. "Black Leadership During the American Reconstruction," Thompson Funeral Home and Thompson Burial Association, Uptown office for your convenience in paying your insurance, 612 Coffee Street, Port Gibson, Miss. 39150. [Text printed on the fan. A copy of the fan is in the William Ferris Collection, Southern Folklife Collection, University of North Carolina at Chapel Hill.]

6. Randall Kenan, *Let the Dead Bury Their Dead and Other Stories* (New York: Harcourt Brace & Company, 1992), p. 154.

7. Art Shay, "From the Vault of Art Shay: Remembering Dr. King," January 20, 2014, http://chicagoist.com/2014/01/20/from_the_vault_of_art_shay_classic_1.php#photo-1.

8. "Ronald Bailey, "Picturing the Black Experience and Framing the Civil Rights Photography of Ernest C. Withers" in Ronald Bailey and Michele Furst, editors, *Let Us March On! Selected Civil Rights Photographs of Ernest C. Withers: 1955–1969* (Roxbury, MA: Massachusetts College of Art and Northeastern University, 1992), p. 17.

9. "Pete Seeger" in William Ferris, *The Storied South* (Chapel Hill: University of North Carolina Press, 2013), pp. 173–74.

10. Charles Moore, *Powerful Days: The Civil Rights Photography of Charles Moore* (Tuscaloosa, AL: The University of Alabama Press, 1991), p. 6.

11. Don Carleton, Douglas Brinkley, and Amy Bowman, *Selma 1965: The Photographs of Spider Martin* (Austin: University of Texas Press, 2015), p. 44.

12. Carleton, Brinkley, and Bowman, p. 44.

13. *New York Daily News*, September 1, 2013.

14. Telephone interview with Doris Derby on February 18, 2020.

Segregated waiting room in
Memphis bus station.

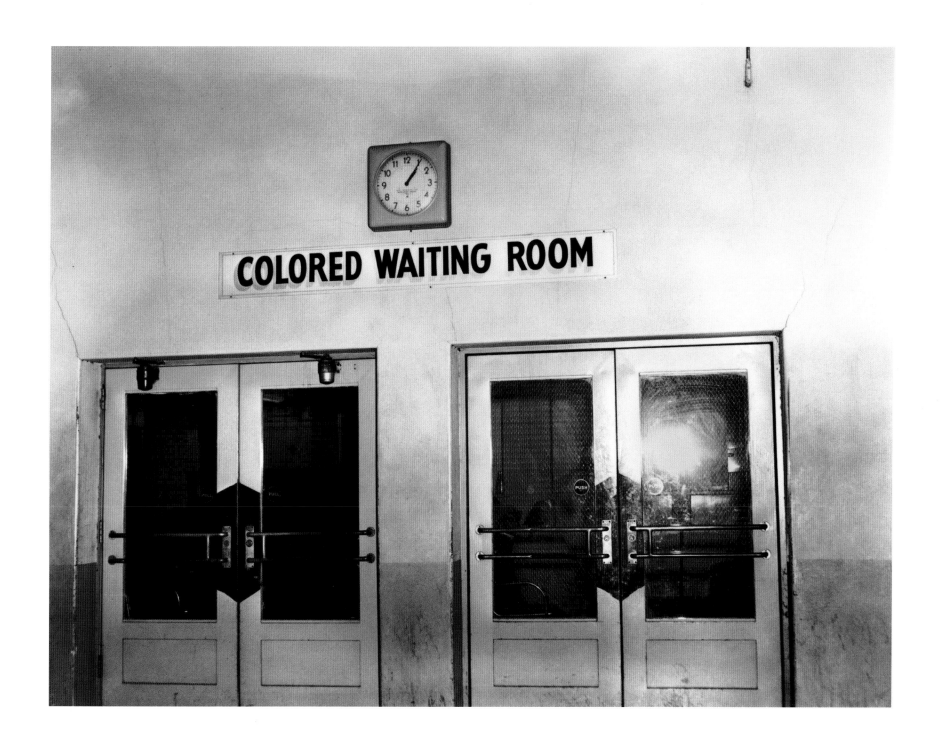

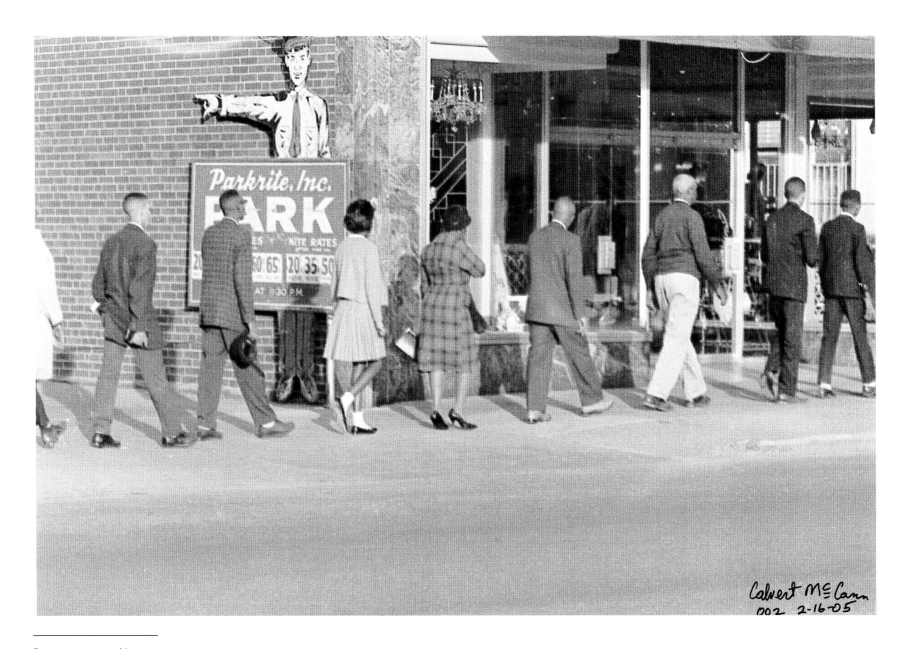

Demonstrators marching
past stores on Main Street,
Lexington, Kentucky, 1960.

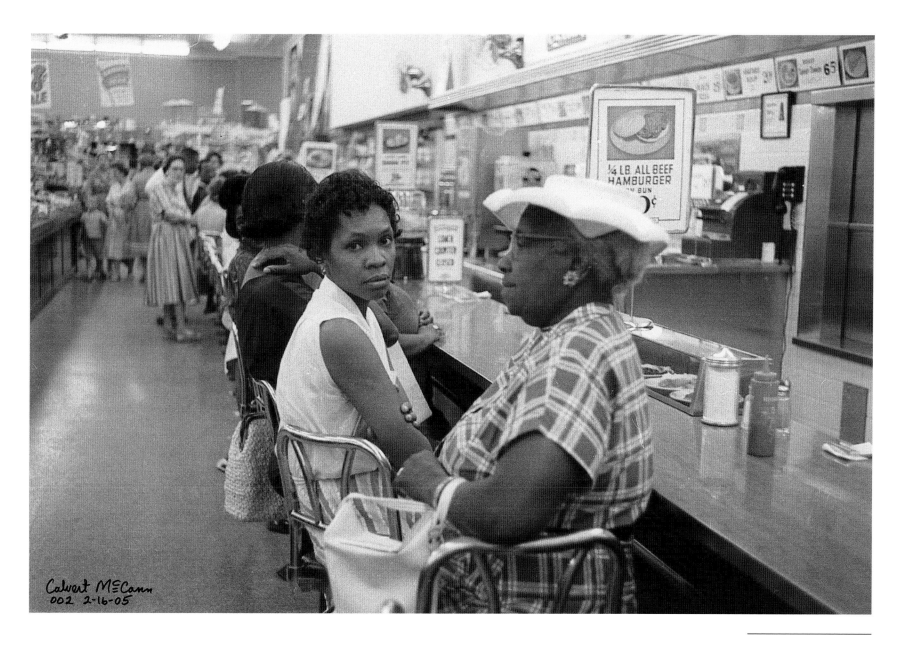

Women at sit-in at a lunch counter, Lexington, Kentucky, 1960.

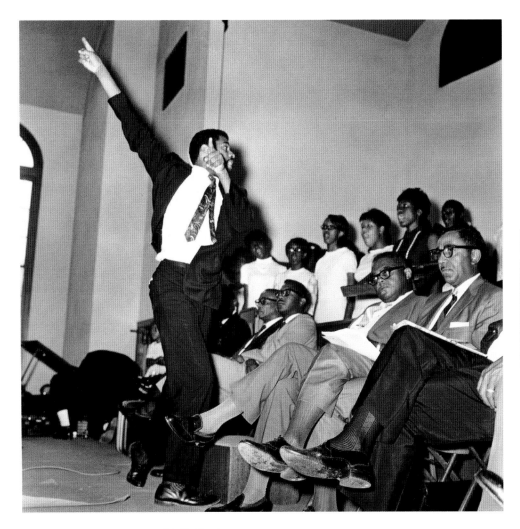

Minister directs choir at SCLC convention rally at SME church.

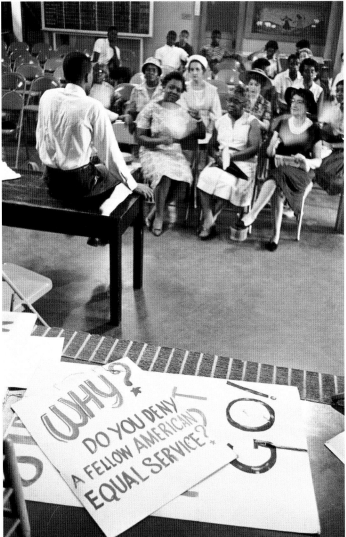

Protesters attending a training session, Charlotte, North Carolina, 1960.

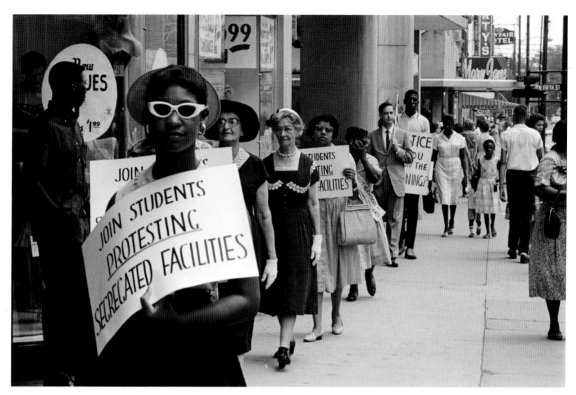

African Americans and a few whites picket Charlotte department stores, woman with sunglasses and holding a sign looking into the camera, 1960.

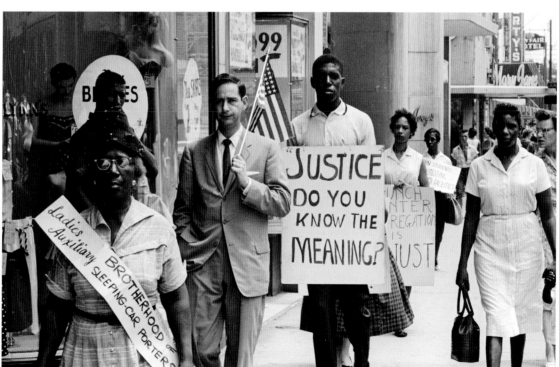

African Americans and a few whites picket Charlotte department stores, elderly woman wearing a sash, 1960.

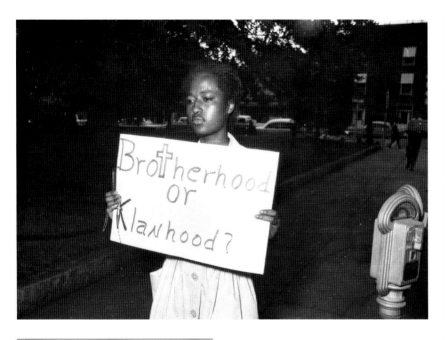

Protester with sign reading "Brotherhood or Klanhood?" Farmville, Virginia, 1963.

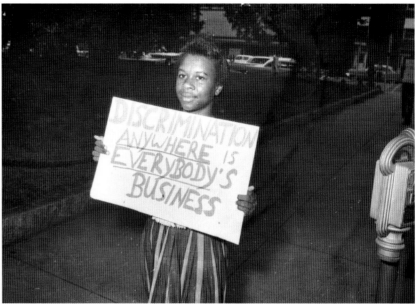

Protester with sign reading "Discrimination Anywhere Is Everybody's Business." Farmville, Virginia, 1963.

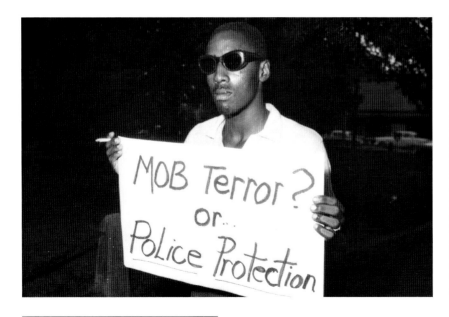

Protester with sign reading "Mob Terror? or Police Protection." Farmville, Virginia, 1963.

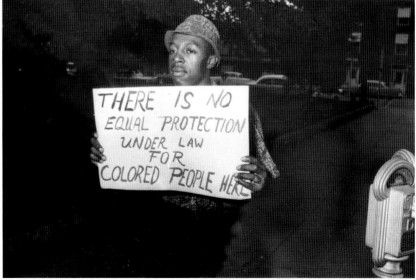

Protester with sign reading "There Is No Equal Protection Under Law for Colored People Here." Farmville, Virginia, 1963.

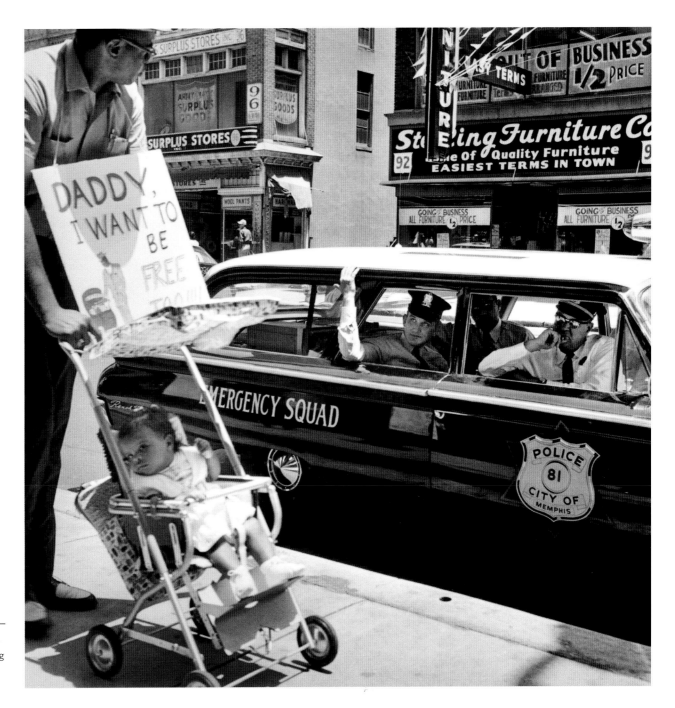

William Edwin Jones pushes daughter Renee Andrewnetta Jones (eight months old) during protest march on Main Street, Memphis, Tennessee, August 1961.

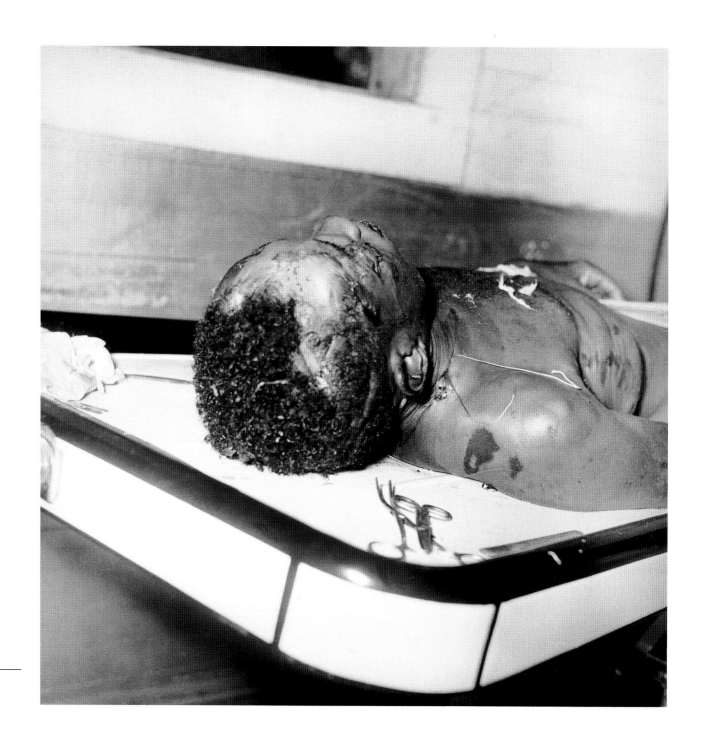

Lynching victim lying on morgue table,
Clarksdale, Mississippi, 1960.

Name: BRADEN, CARL, W/M
DOB Age 48, 5'10", 165 lbs., blue eyes, gray, curly hair.
Address: 4403 Virginia Avenue, Louisville, Kentucky.
Occ.: Field Organizer S C E F
Arrest: On 2/27/61, U. S. Supreme Court upheld a conviction for contempt of Congress on charges by the House Committee on un-American activities after Braden refused to tell the House Committee whether he was a Communist.
Organization: Field Organizer S C E F
Associates: James A. Dumbrowske, Edgar A. Love, Fred Lee Shuttlesworth, Benjamin E. Smith and others.

Note: He has been publicly identified as a Communist Party Member.

Note: He, his wife and others allegedly burned a house, which had been purchased by Negroes in a White community to incite

racial strife between Negroes and Whites.

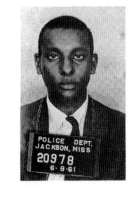

Name: CARMICHAEL, STOKELY, N/M
DOB
Address:
Occ.:
Arrest: 6/8/61 Breach of Peace, Jackson, Mississippi; 6/15/61 Breach of Peace, Jackson, Mississippi; 10/18/64 Disobeying an officer and blocking roadway, Jackson, Mississippi; 1/26/65 Unlawful Assembly, Selma, Alabama. FBI # 853 121 D
Organization: S N C C
Associates:

Name: BRADEN, ANNE, W/F
DOB Age 45
Address: 4403 Virginia Avenue, Louisville, Kentucky
Occ.: Editor (The Southern Patriot) 822 Perdido Street, New Orleans, Louisiana
Arrest: 11/4/54 Indicted by Grand Jury for conspiring to damage property to achieve political ends, Louisville, Kentucky.
Organization: S C E F
Associates: Carl Braden, husband, Fred Lee Shuttlesworth, James A. Dombrowski and others.

Note: She has been publicly identified as Member of Communist Party; very active in Civil Rights Movement throughout the South.

Note: She, her husband and others allegedly burned a house, which had been purchased by Negroes in a White community to incite racial strife between Whites and Negroes.

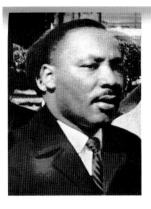

Name: KING, MARTIN LUTHER, JR., N/M
DOB 1/15/29, 5'7", 170 lbs., brown eyes, black hair.
Address: 563 Johnston Street, Atlanta, Ga.
Occ.: President, S C L C
Arrest: 1/26/56, Speeding, P. D., Montgomery, Ala.; 2/22/56, vio. Title 14, Sec. 54, 1940, Code of Ala.; Montgomery, Ala.; 2/29/60, Perjury, S. O., Montgomery, Ala.; 10/19/60, vio. Act 497, Ga. Law of 1960, Misdemeanor, refused to leave premises, P. D., Atlanta, Ga.; 10/26/60, No Drivers License, State Board of Corrections, Atlanta, Ga.; 4/12/63, Vio. Sec. 1159, GCC, Atlanta, Ga.; P. D., Birmingham, Ala.; FBI #169 213 C.
Organization: President, Southern Christian Leadership Conference.
Associates: Left Wing Pro-Communist Groups, functions and organization, Ralph D. Abernathy, Fred Lee Shuttlesworth,

(Left) Carl Braden.

(Right) Stokely Carmichael.

(Left) Anne Braden.

(Right) Martin Luther King Jr., Montgomery, Alabama, 1965.

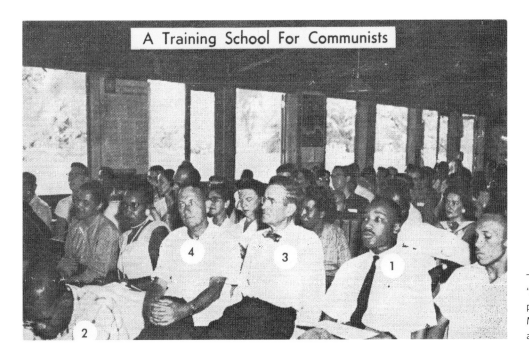

"A Training School for Communists" propaganda photograph in newspaper: Martin Luther King Jr. attending a class at a training school for Communists, 1957.

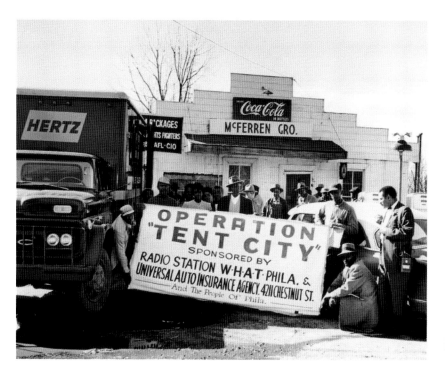

Operation Tent City receives food from
Philadelphia and other cities, Somerville,
Tennessee, 1960.

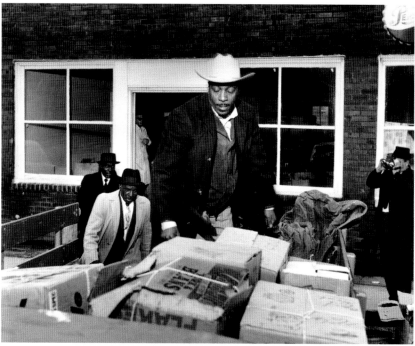

Dick Gregory delivers food to farmers'
families, Clarksdale, Mississippi, 1960.

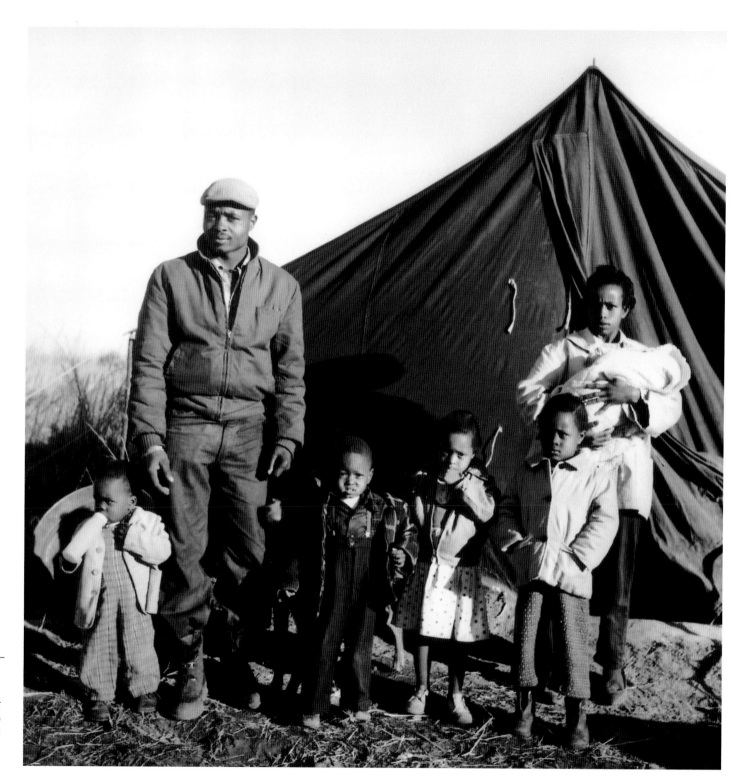

"Tent City" family, created when black families were evicted from their homes for voting in 1960. They took up residence on the property of Shep Toles. Fayette County, Tennessee, 1960.

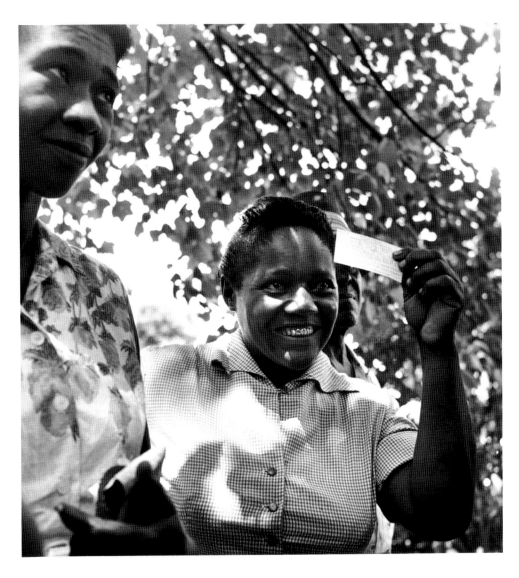

Young woman receives her voter registration card. Fayette County, Tennessee, 1960.

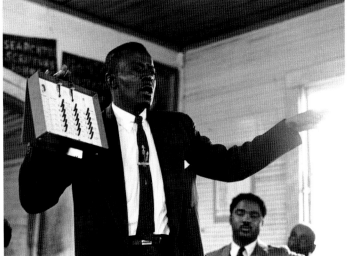

Willie Lee Wood Sr. demonstrating a voting machine for an audience in a small wooden church building in Prattville, Alabama, 1966.

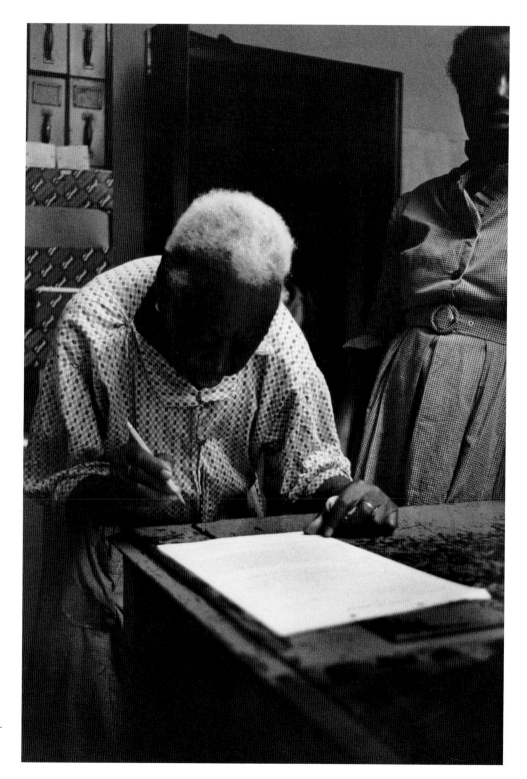

105-year-old woman (former slave) registers
to vote in Greenville, Mississippi, 1965.

1961

Freedom Rides, Jackson, MS, Birmingham, AL

Freedom Rides were demonstrations in which black and white activists rode Greyhound and Trailways buses through the South to integrate the buses and the bus stations. The first major violence against the activists was in Rock Hill, South Carolina, when John Lewis and Albert Bigelow were beaten at a bus station. Aided by local police, mobs of Ku Klux Klan supporters attacked the Freedom Riders in Anniston, Birmingham, and Montgomery, Alabama. After securing protection from the National Guard and state police in Mississippi, the Freedom Rides continued to Jackson, where the riders were arrested upon arrival for violating local segregation ordinances. The protests continued through 1961 when riders rode buses to McComb, Mississippi; Monroe, North Carolina; and Albany, Georgia.

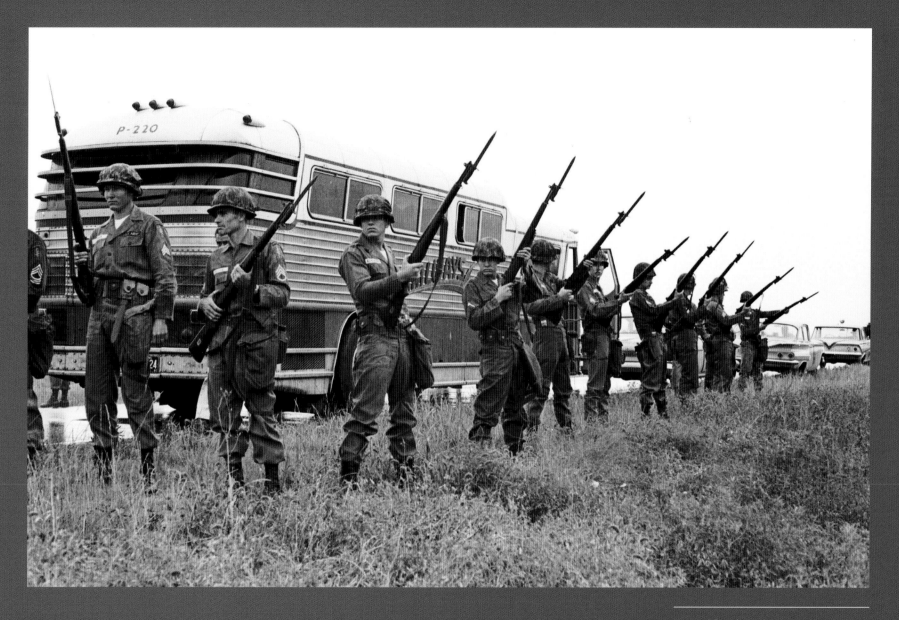

National Guard members protecting the bus for the Freedom Riders leaving Montgomery, Alabama, for Jackson, Mississippi.

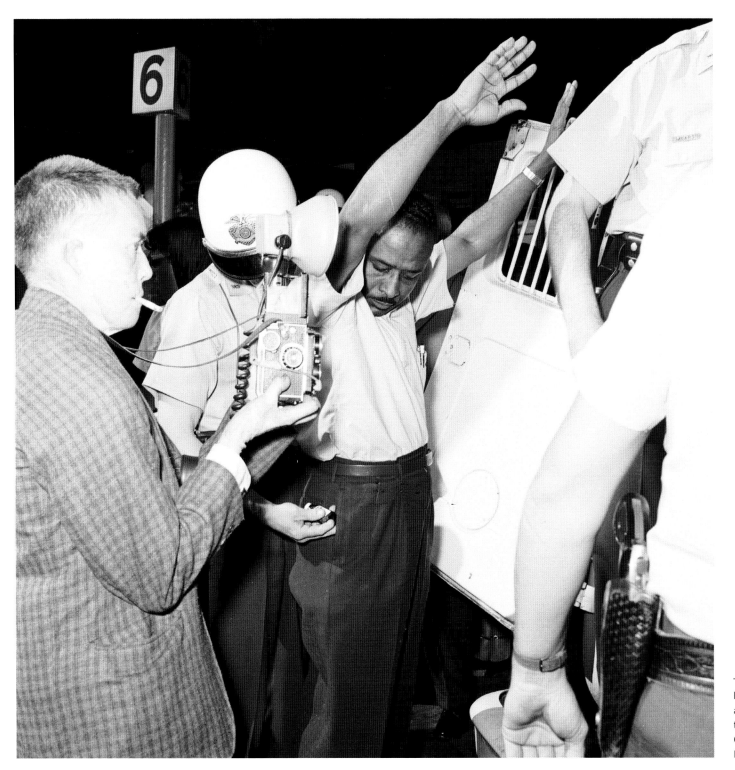

Police officers arresting a Freedom Rider after the group's arrival at the Greyhound station in Birmingham, Alabama.

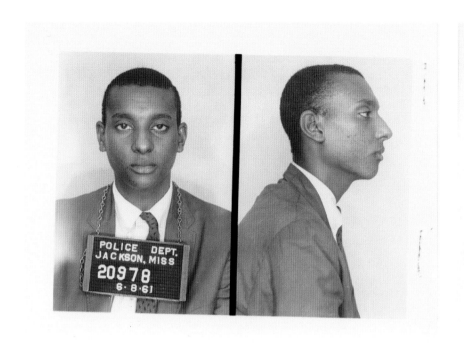

Freedom Rider mug shot (Stokely Carmichael).

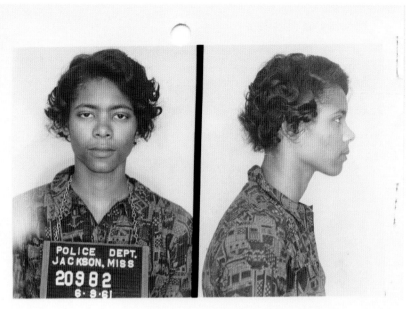

Freedom Rider mug shot (Patricia Bryant).

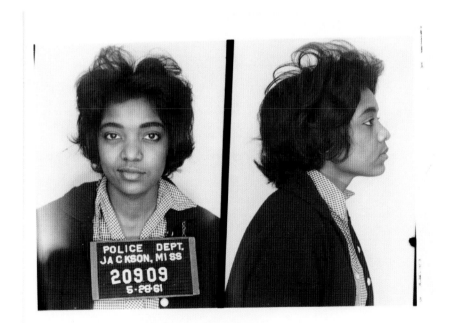

Freedom Rider mug shot (Catherine Burks).

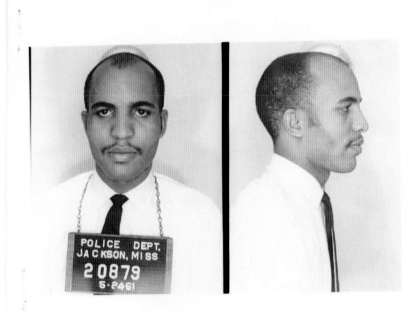

Freedom Rider mug shot (James L. Bevel).

1962

James Meredith Integrates University of Mississippi, Oxford, MS

After a lengthy legal battle, on October 1, 1962, James Meredith became the first African American student to enroll at the University of Mississippi. The evening before Meredith was admitted, a crowd of three thousand people rioted on campus. During the riot, they burned cars, threw rocks at federal marshals, and murdered two people. French journalist Paul Guihard, who was on assignment for Agence France-Presse, was killed with a gunshot wound to his back, and Ray Gunter, a white jukebox repairman, died with a bullet wound in his forehead. Their deaths were described as execution-style killings. Over three hundred people were injured, and fifty-five US Marshals and forty soldiers and National Guardsmen who were guarding James Meredith were wounded.

In response to the riot, President Kennedy ordered ten thousand US Army military police, US Border Patrol, US Navy medical personnel, and federalized Mississippi National Guard to the campus to restore order.

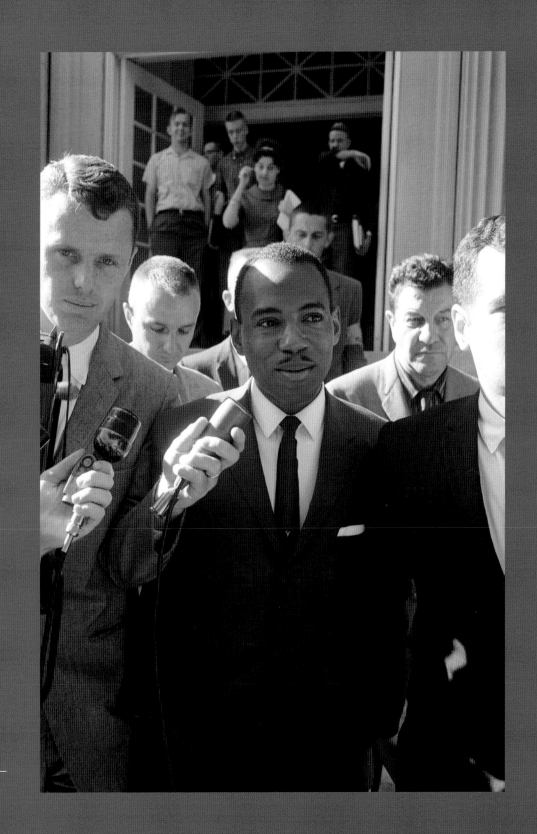

James Meredith being interviewed.

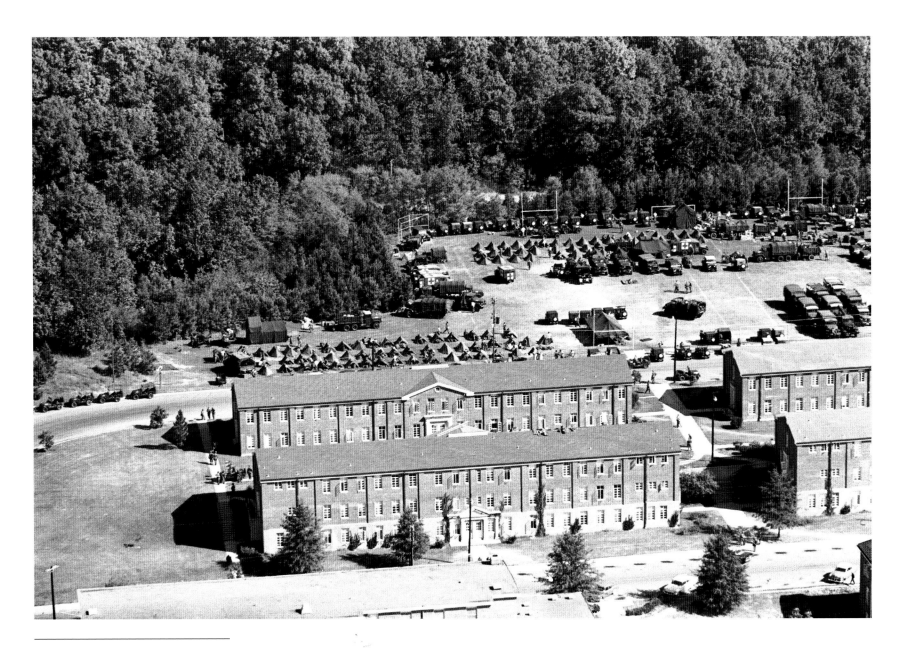

Aerial shot of University of Mississippi,
detailing National Guard presence.

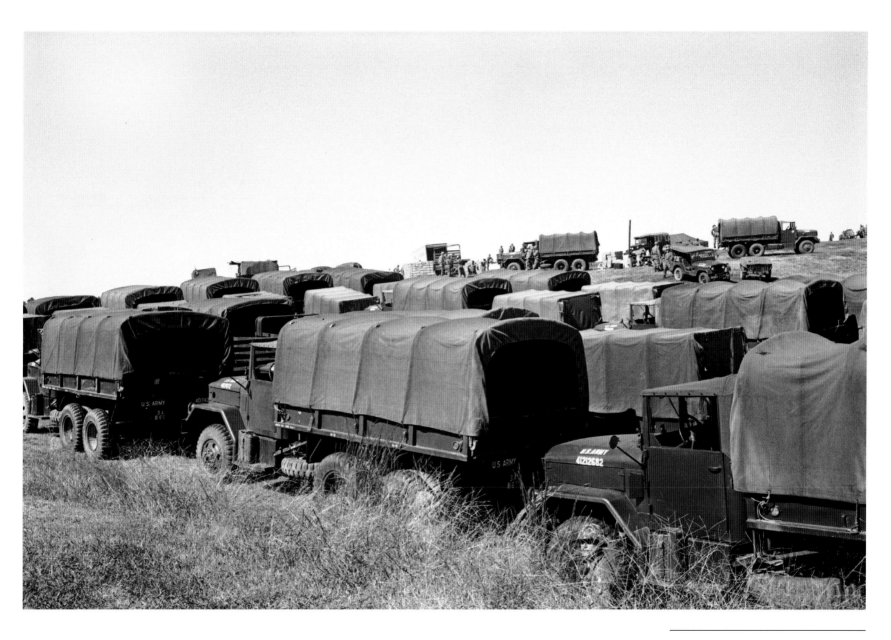

National Guard trucks near University of Mississippi.

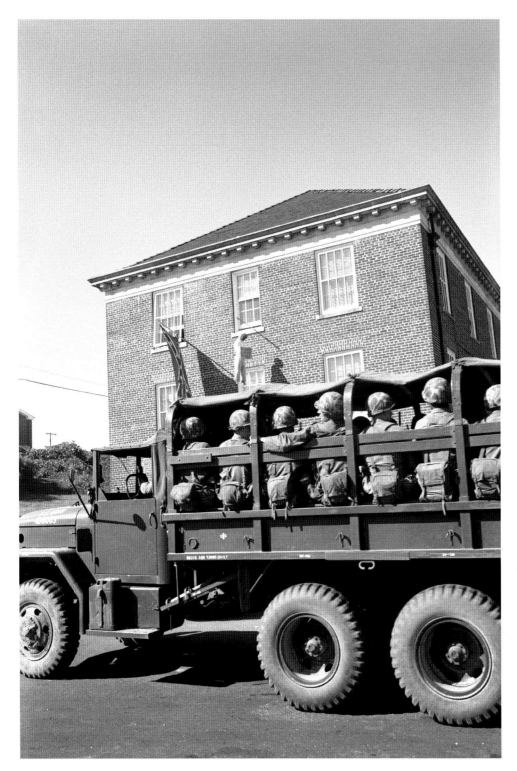

National Guard in Oxford, Mississippi; effigy
of James Meredith visible.

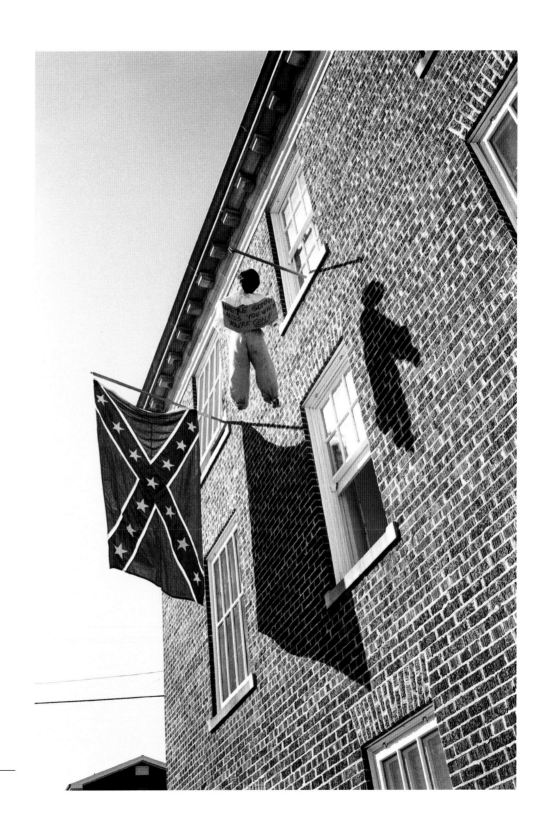

Effigy of James Meredith hanging.

1963

March on Washington

The March on Washington on Wednesday, August 28, 1963, drew 250,000 people who gathered to support civil and economic rights for African Americans. Martin Luther King Jr. spoke to the demonstrators and called for an end to racism as he stood in front of the Lincoln Memorial and delivered his historic "I Have a Dream" speech. The march was one of the largest political rallies in history and influenced the passage of the Civil Rights Act of 1964.

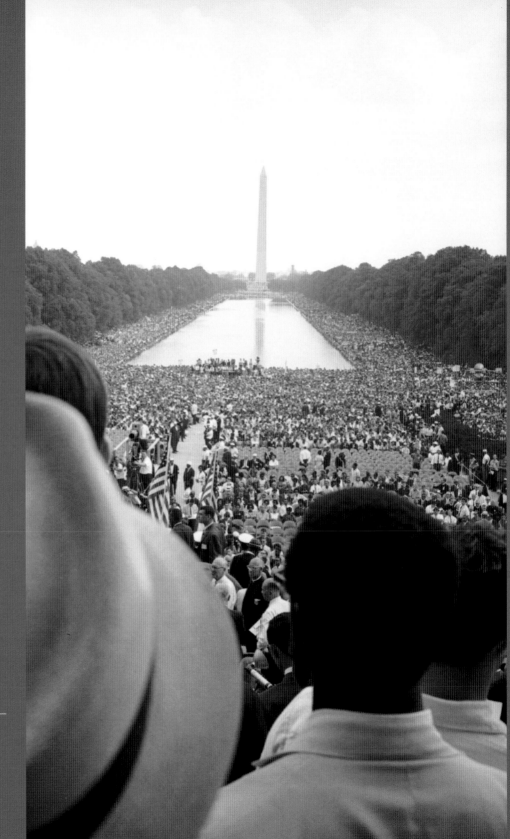

Civil rights march on Washington, DC, view from Lincoln Memorial towards Washington Monument.

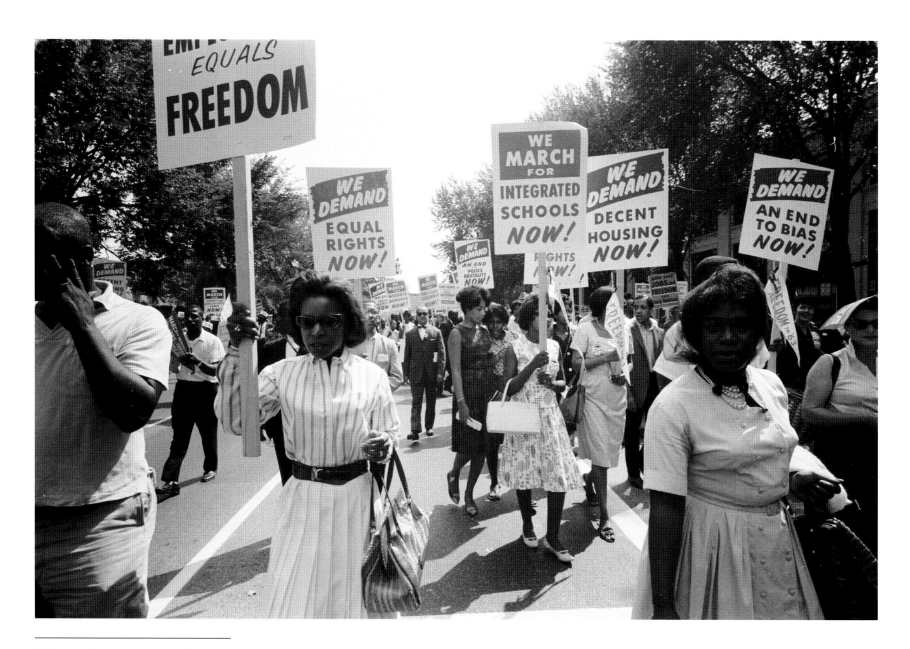

African American protesters carry signs
that call for equal rights, integrated schools,
and an end to housing discrimination.
Washington, DC.

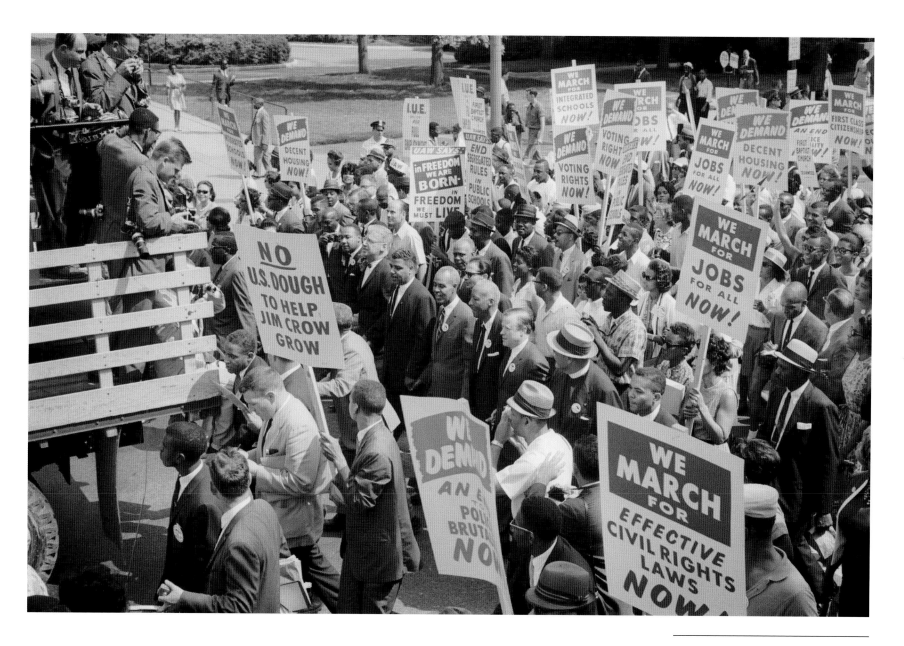

Civil rights leaders, including Martin Luther King Jr., are surrounded by crowds carrying signs, marching in DC.

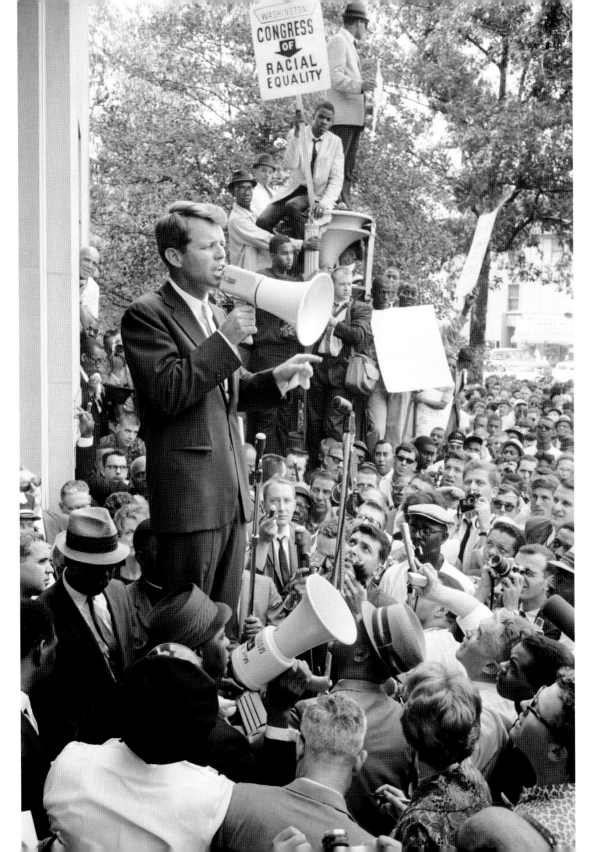

Attorney General Robert F. Kennedy speaking to a crowd of African Americans and whites through a megaphone outside the Justice Department.

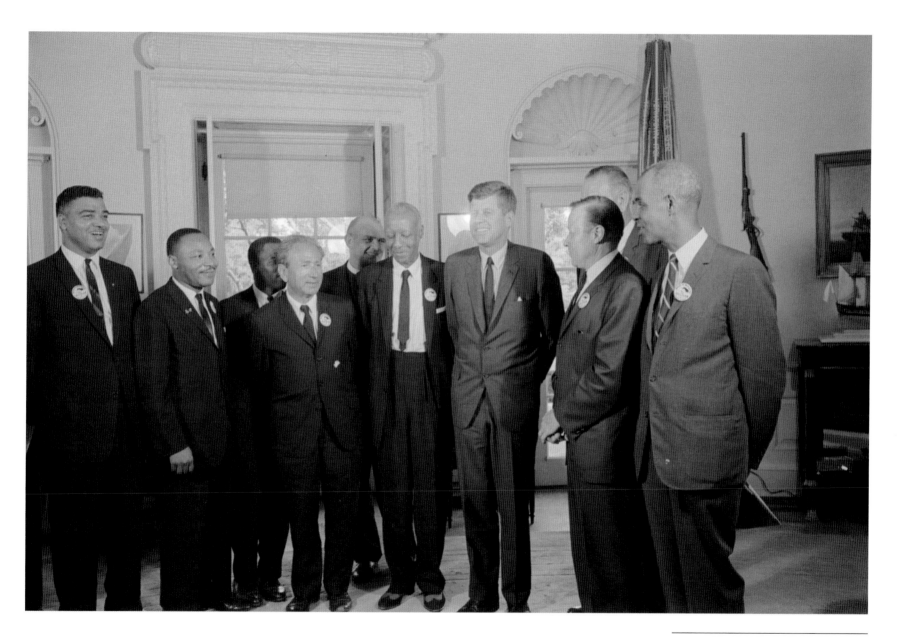

Civil rights leaders meet with John F Kennedy.

1964

Ku Klux Klan Rally in Salisbury, NC

Salisbury, North Carolina, was the home of Bob Jones, a high school dropout who was discharged from the Navy because he refused to salute a black officer. Jones became the grand dragon of the Ku Klux Klan in North Carolina, and he and his wife Sybil registered ten thousand new members of the Klan. In addition to Klan rallies, Jones encouraged members to wear their white robes and walk with their families in streets.

Both Bob Jones and his wife Sybil were featured speakers at nighttime Klan rallies. At the end of each rally, Klansmen burned a sixty-foot-tall cross as they sang "The Old Rugged Cross."

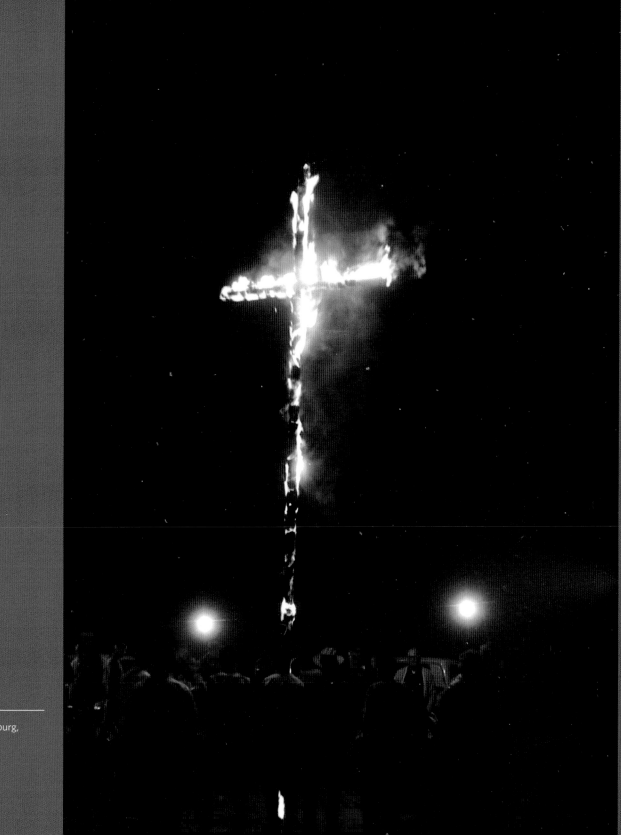

KKK Rally, Hattiesburg,
Mississippi, 1965.

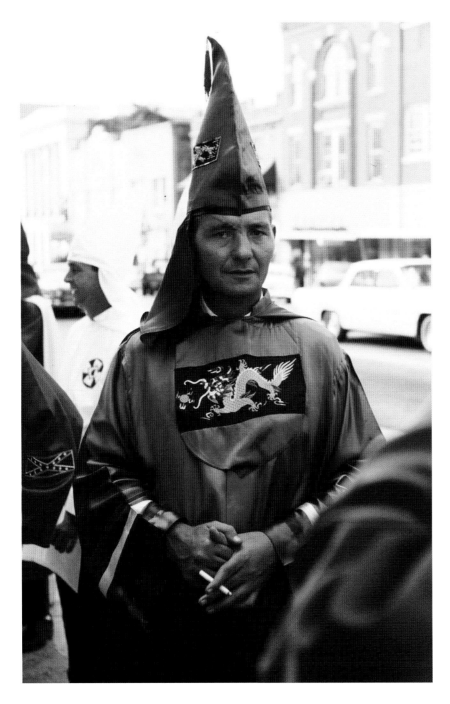

Grand Dragon J. Robert Jones in Salisbury,
North Carolina, standing with cigarette, 1964.

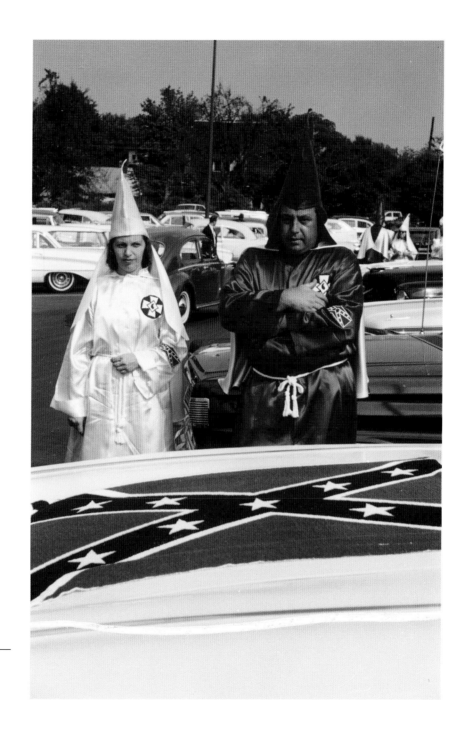

Grand Dragon J. Robert Jones in Salisbury, North Carolina, standing with his wife in front of a car, 1964.

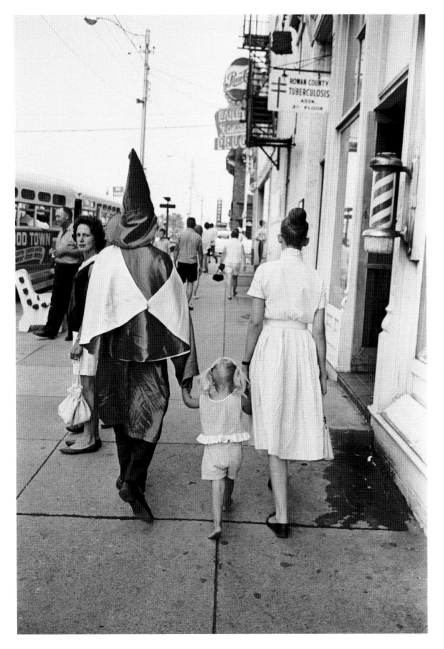

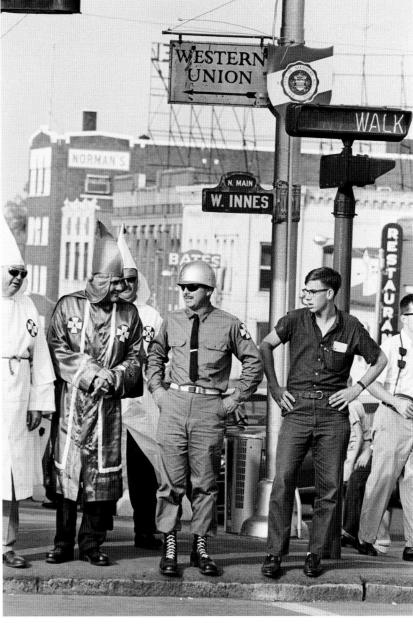

Ku Klux Klan rally in Salisbury; Klan member
in robes walks down the street with wife
and daughter, 1964.

Ku Klux Klan rally in Salisbury; marching Klan
members stopped at crosswalk beneath a
Western Union sign, 1964.

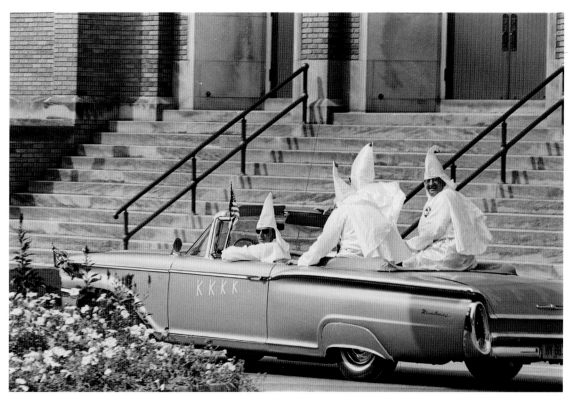

Ku Klux Klan rally in Salisbury; Klan members drive past in convertible, 1964.

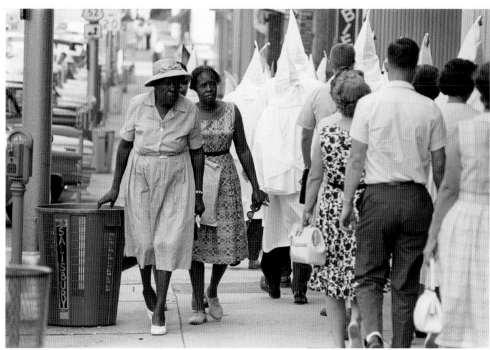

Ku Klux Klan rally in Salisbury; three black women move past marching Klan members, 1964.

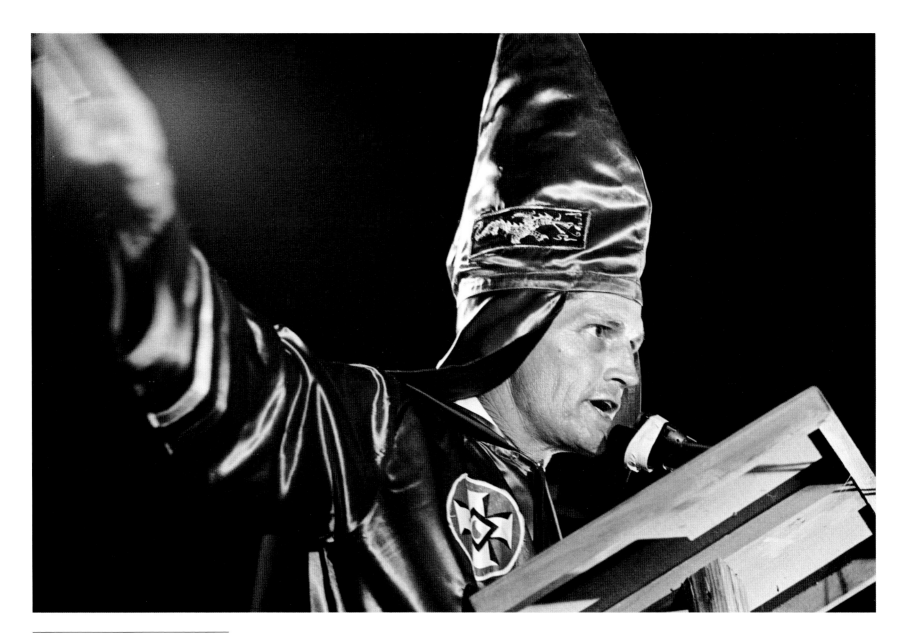

Ku Klux Klan rally in Salisbury; speaker swipes
his hand across the frame, 1964.

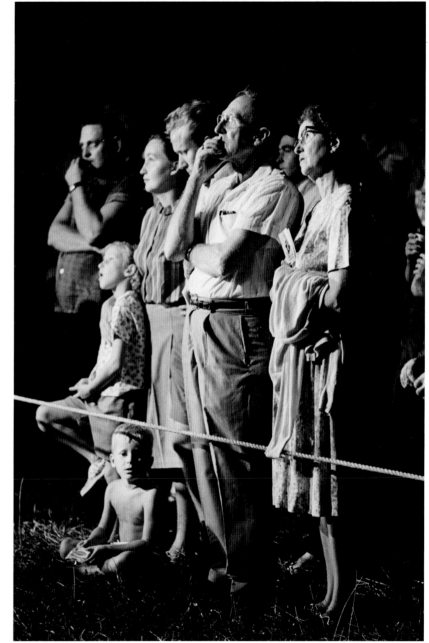

Ku Klux Klan rally in Salisbury; small boy looks into the camera, 1964.

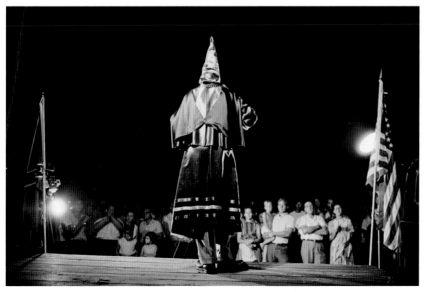

Ku Klux Klan rally in Salisbury; speaker from behind the stage, 1964.

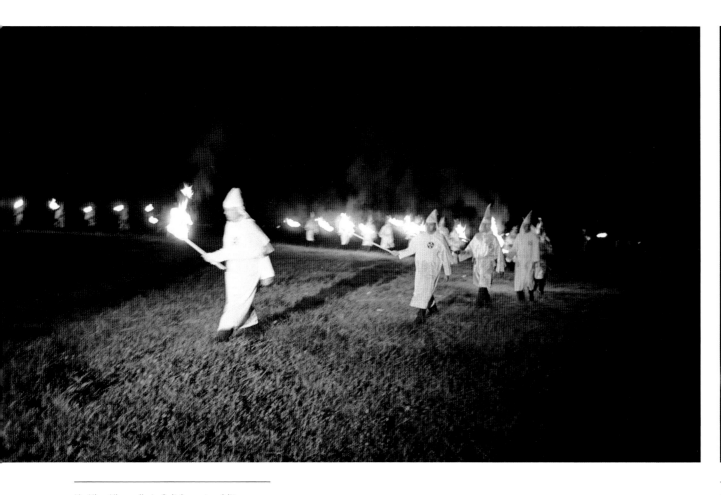

Ku Klux Klan rally in Salisbury; torchlit
procession of robed Klan members, 1964.

Ku Klux Klan rally in Salisbury; Klan members
circled about a blazing cross, 1964.

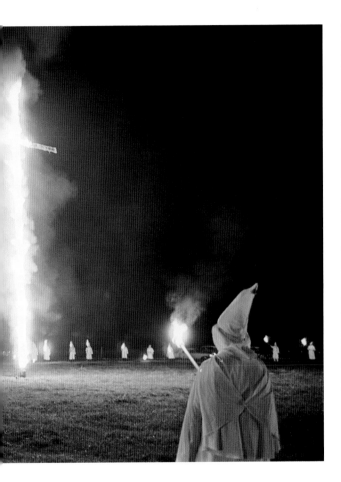
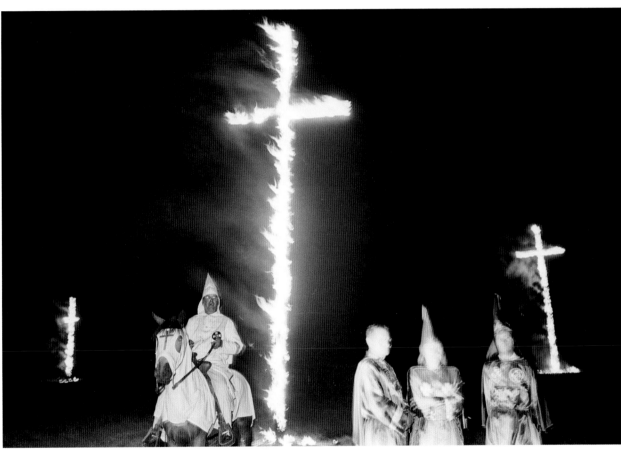

Ku Klux Klan rally in Salisbury; Klan members
circled about a blazing cross, 1964.

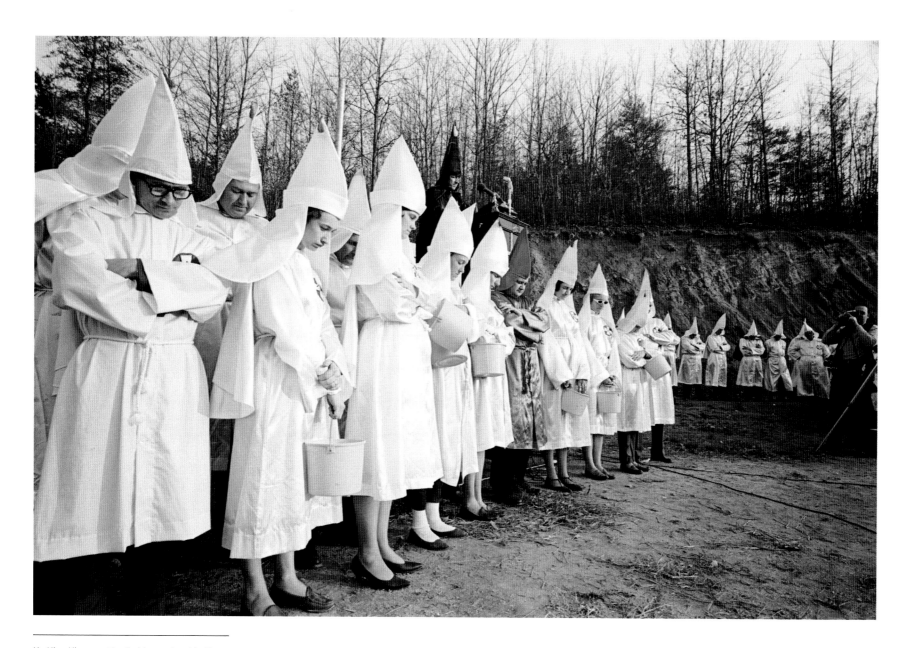

Ku Klux Klan meeting in Morganton, North
Carolina; Klan members lined up, presumably
in prayer, before the event, 1965.

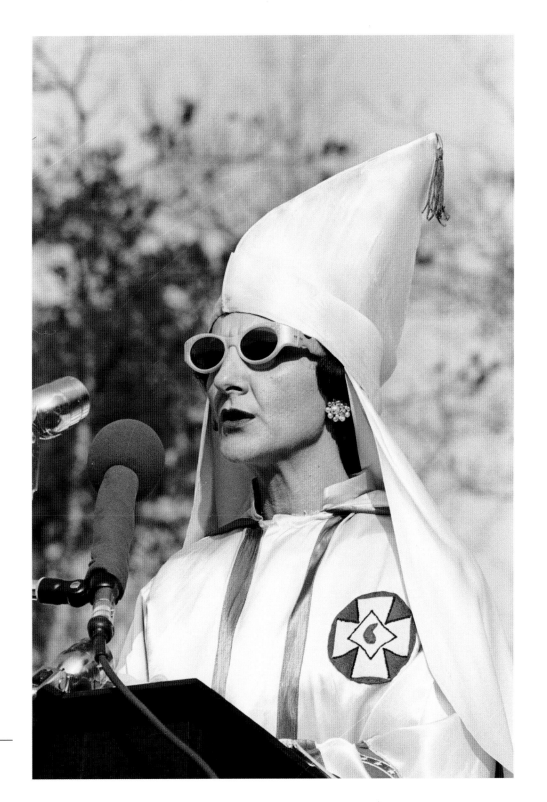

Ku Klux Klan meeting in Morganton, North
Carolina; Sybil Jones speaks, 1965.

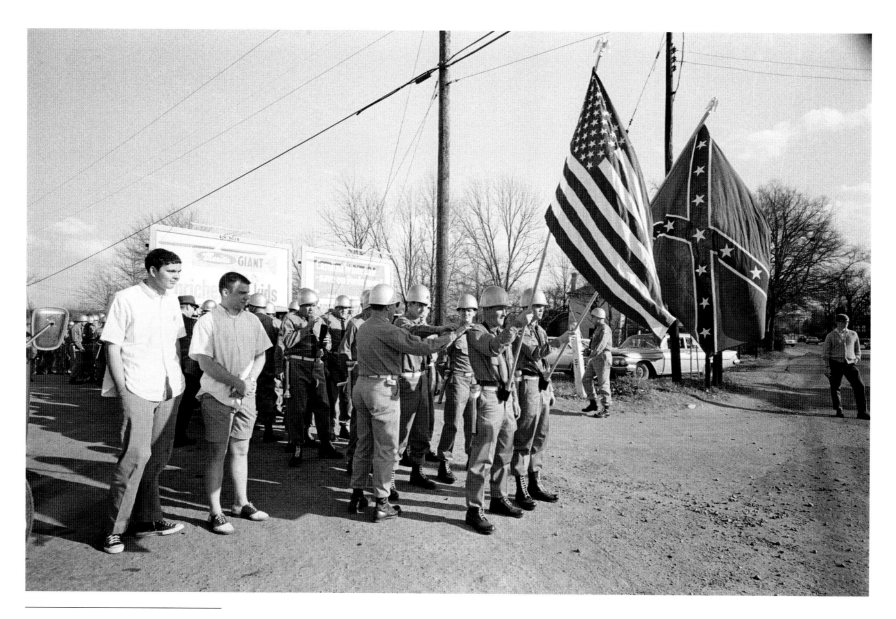

Ku Klux Klan marching in Pineville, North
Carolina; marchers with American flag and
Confederate battle flag held aloft, 1967.

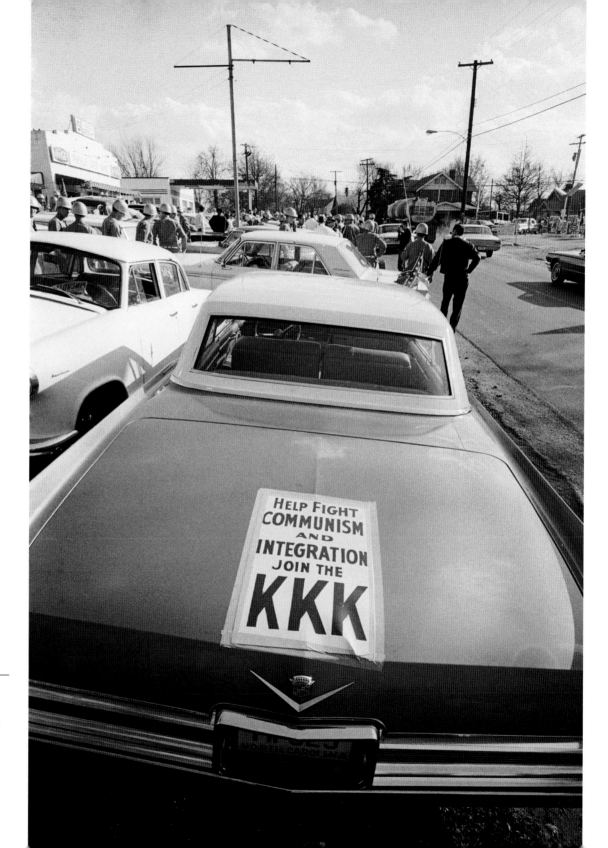

Ku Klux Klan marching in Pineville, North Carolina; car with sticker that reads, "Help Fight Communism and Integration: Join the KKK," 1967.

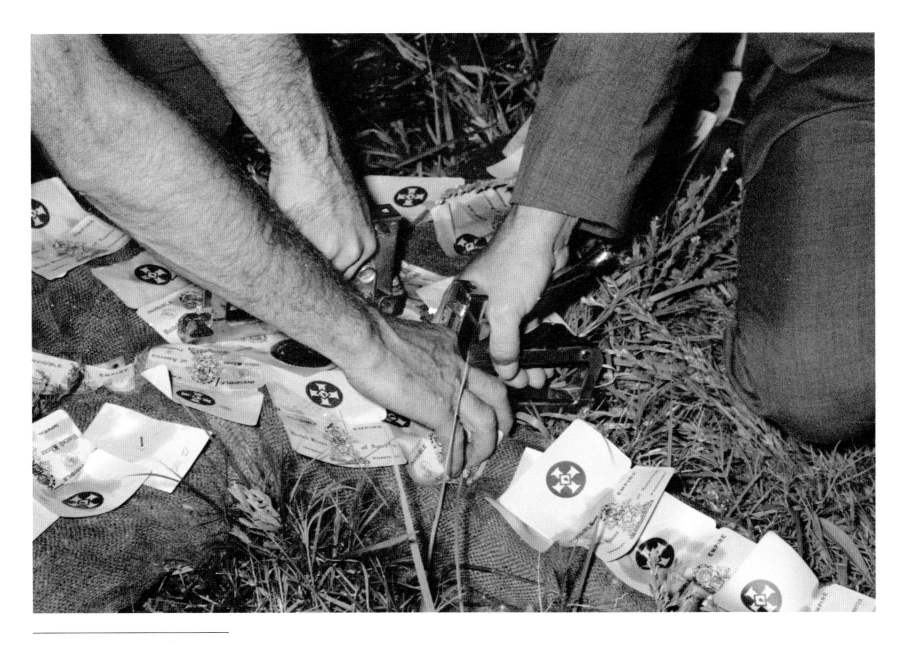

Ku Klux Klansmen from the North Carolina
Piedmont burning their membership cards on
a cross, stapling cards to the cross, 1969.

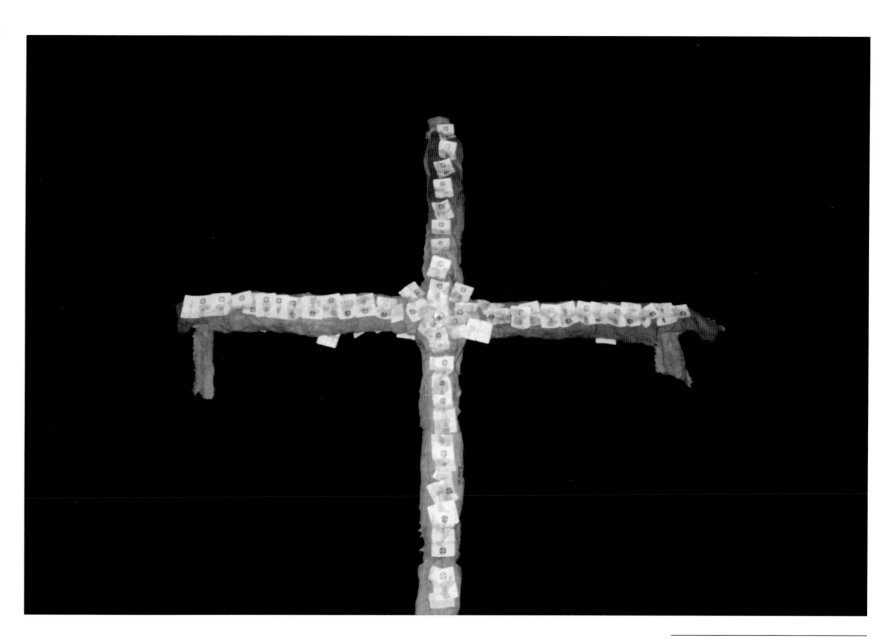

Ku Klux Klansmen from the North Carolina Piedmont burning their membership cards on a cross, erect cross with membership cards, 1969.

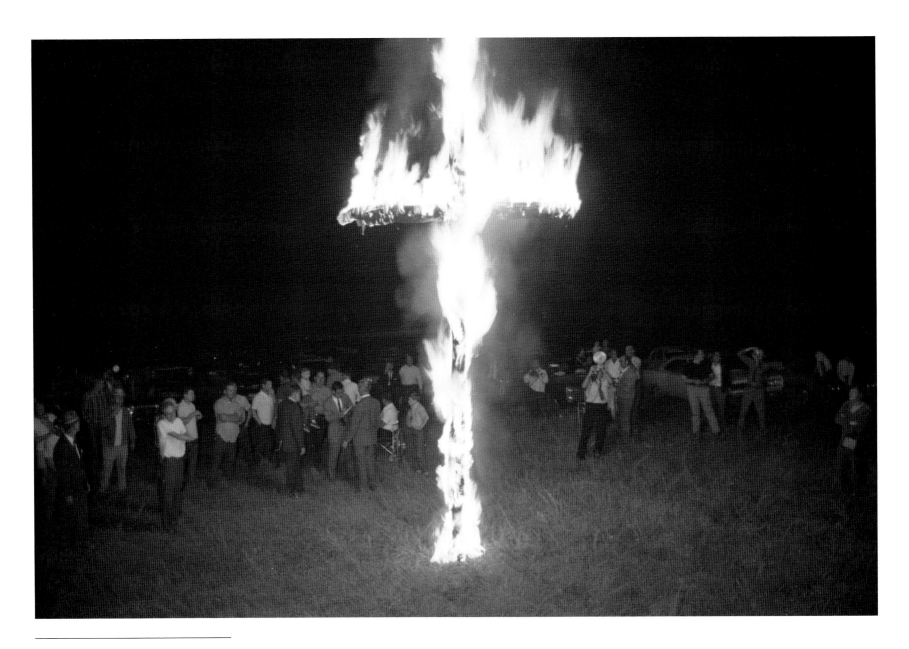

Ku Klux Klansmen from the North Carolina
Piedmont burning their membership cards
on a cross, cross ablaze, 1969.

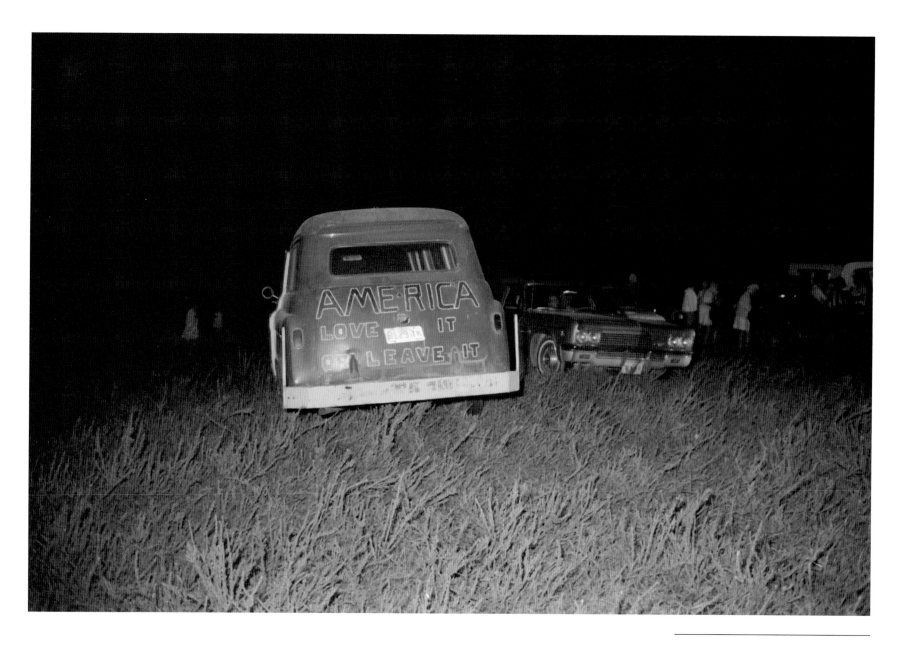

Ku Klux Klansmen from the North Carolina Piedmont burning their membership cards on a cross, painted car with the words "America: Love It or Leave It," 1969.

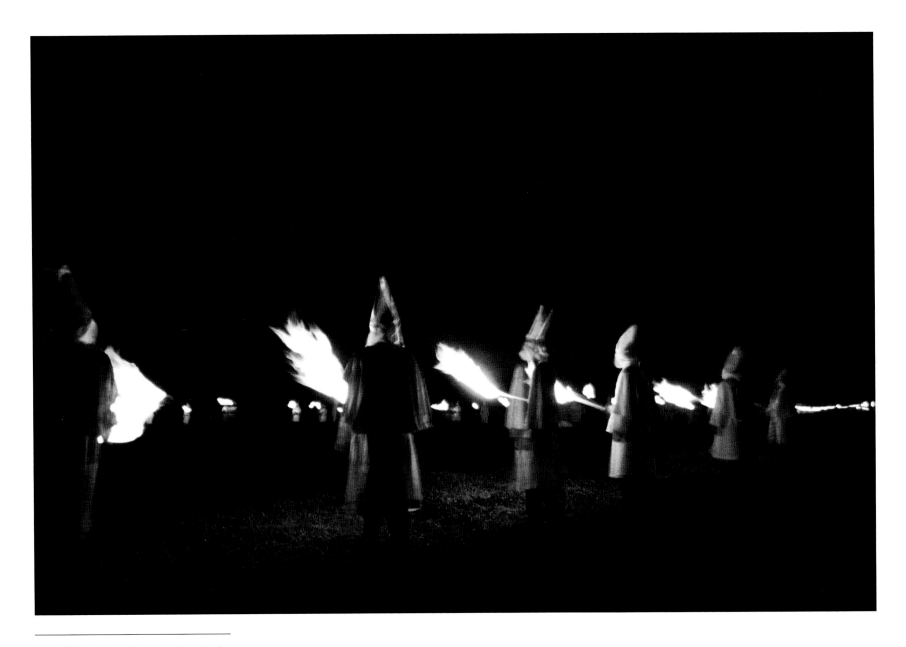

1960s KKK activity in North Carolina; robed
members with torches circle.

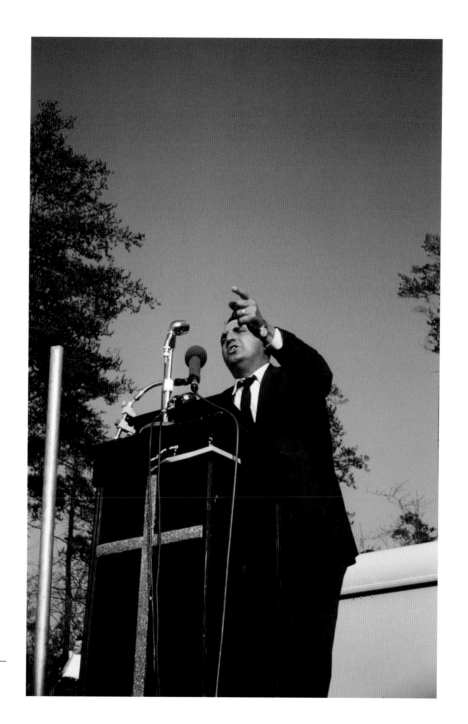

1960s KKK activity in North Carlina; speaker at rally.

1965

Selma to Montgomery March

Three "Montgomery Marches" were held in 1965 along the fifty-four-mile US Route 80, known in Alabama as the "Jefferson Davis Highway" from Selma, Alabama, to the state capital in Montgomery. The marches were organized to support voter registration and to highlight racism in the American South. They brought national support to the Voting Rights Act that was passed that year.

During the first march on March 7, 1965, state troopers attacked unarmed marchers in an event known as "Bloody Sunday" and left Amelia Boynton unconscious lying on the Edmund Pettus Bridge. After Martin Luther King Jr. led the second march on March 9, civil rights activist James Reeb, a Unitarian Universalist minister from Boston, was beaten to death by whites.

In response to violence by whites to the first two marches, President Lyndon Johnson committed 1,900 members of the Alabama National Guard under federal command, as well as FBI agents and federal marshals to protect twenty-five thousand people who marched from Selma to Montgomery led by Martin Luther King Jr. Reverend King and the marchers reached Montgomery after four days. Today the highway is named the "Selma to Montgomery Voting Rights Trail" and is a designated US National Historic Trail.

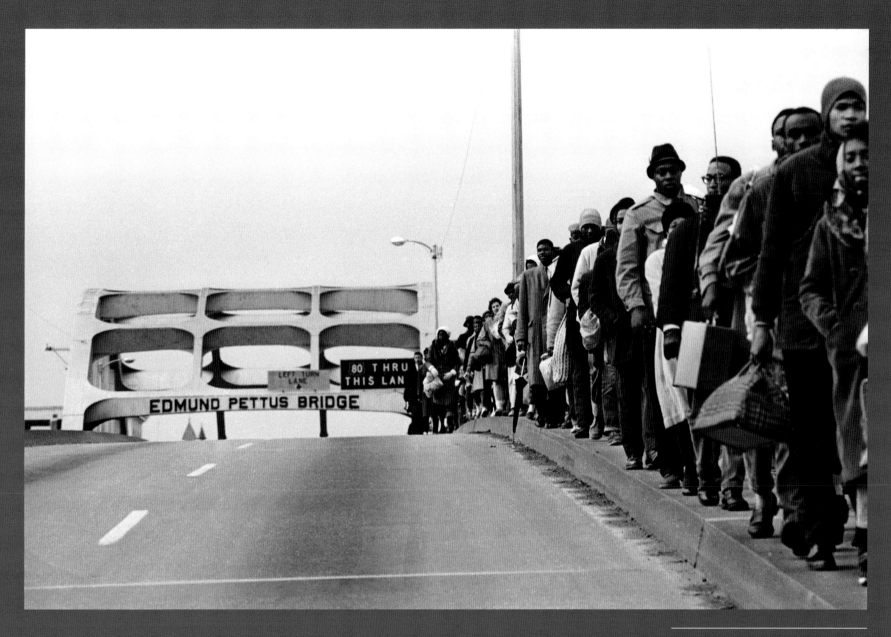

Carrying satchels and suitcases, six hundred marchers make their way over the Edmund Pettus Bridge.

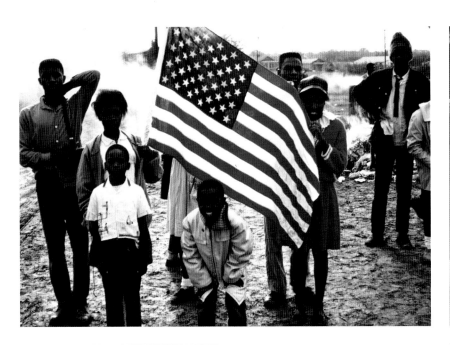

African American children with an American flag, probably during the Selma to Montgomery March.

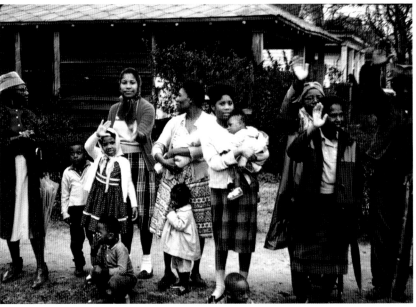

African American women, children, and an older man waving to Selma to Montgomery marchers from the sidewalk.

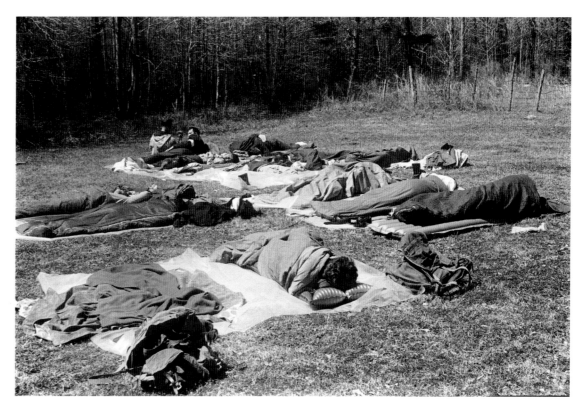

Marchers resting during the march from Selma to Montgomery, Alabama.

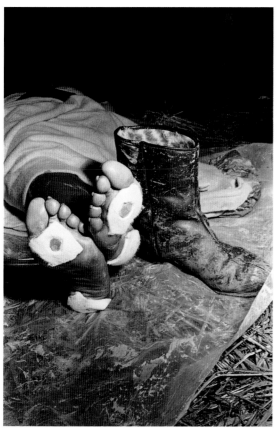

A marcher's blistered feet bear witness to the grueling nature of the fifty-four-mile march from Selma to Montgomery.

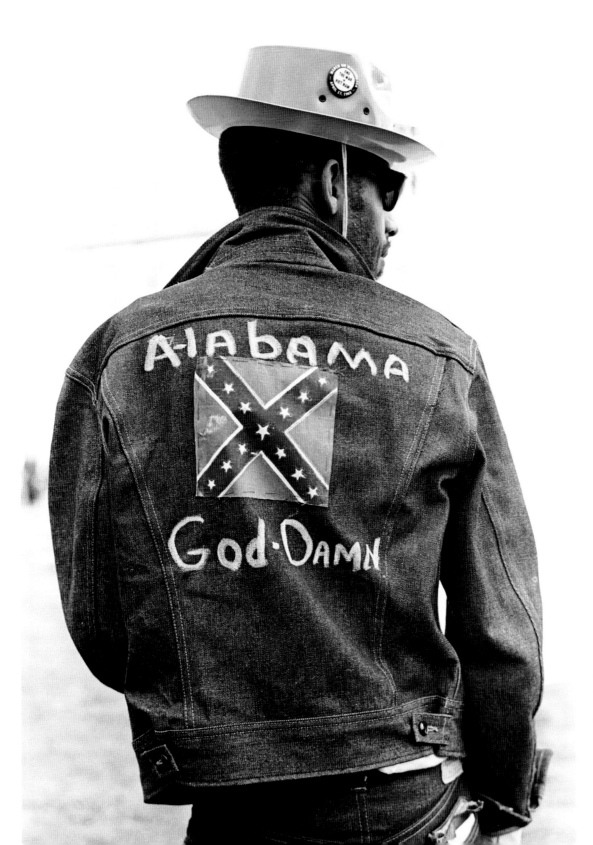

Unidentified man on the Selma to Montgomery March for voting rights wears a jacket painted with the words "Alabama God-Damn."

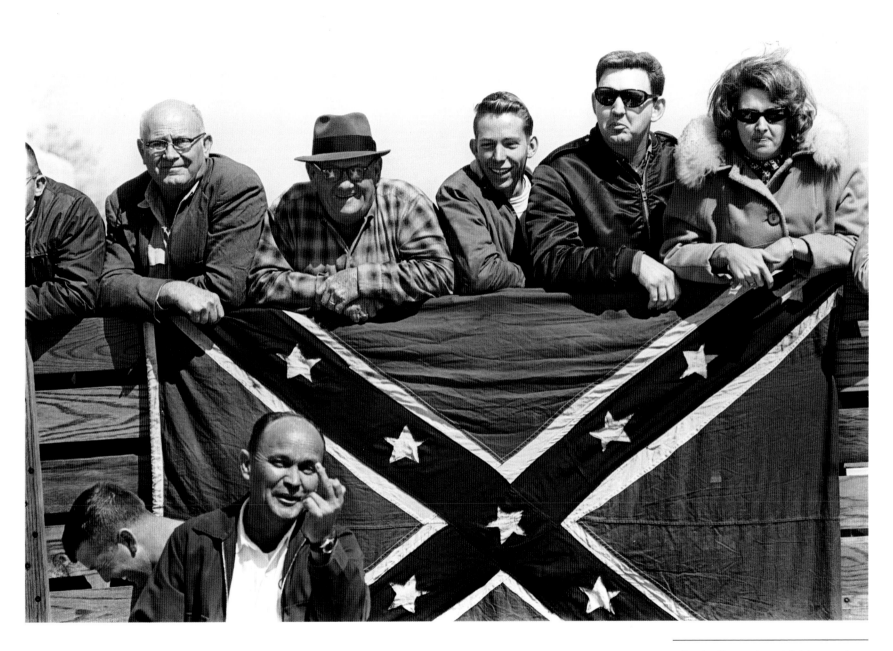

White hecklers confront civil rights marchers from behind a Confederate flag.

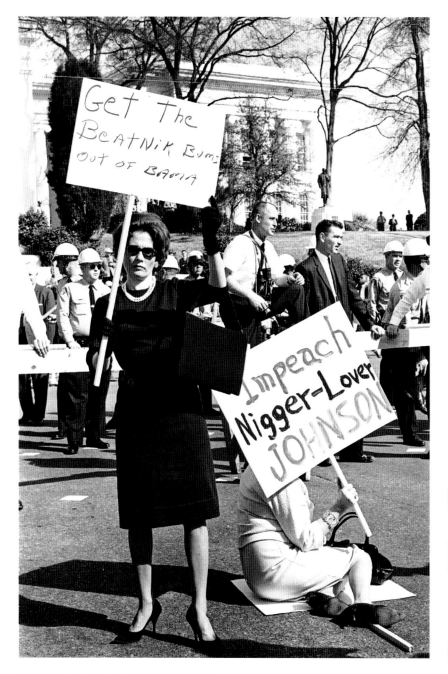

Counter-demonstrators in Montgomery, Alabama.

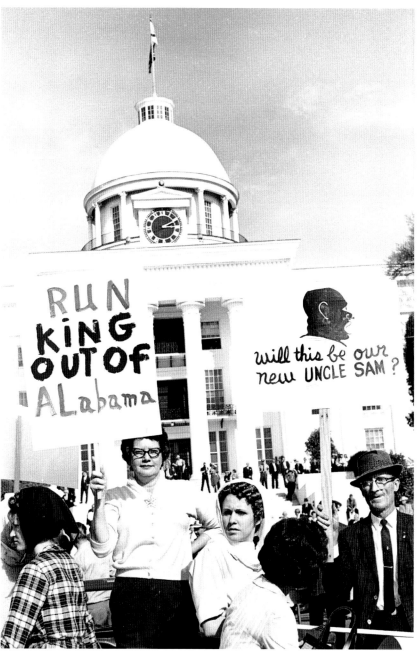

By Alabama state capitol, counter-demonstrators carry signs protesting the voting rights marchers led by Martin Luther King Jr.

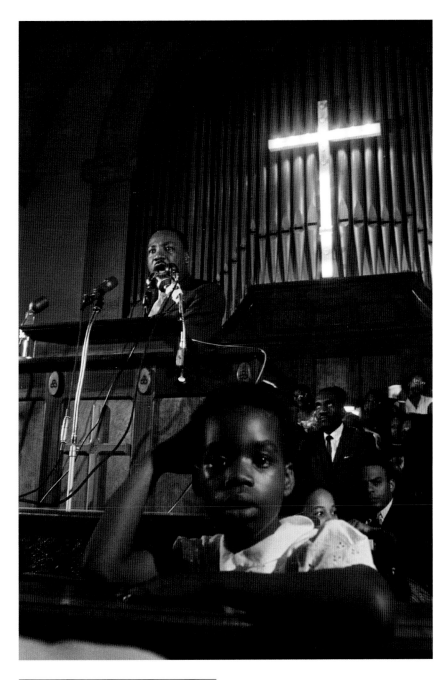

Martin Luther King Jr. speaking to an audience
at Brown Chapel in Selma, Alabama, 1966.

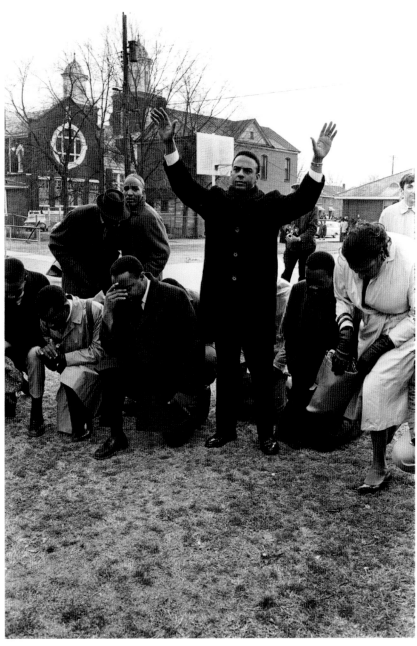

Rev. Andrew Young leads march organizers in
prayer across the street from Brown Chapel
AME Church in Selma.

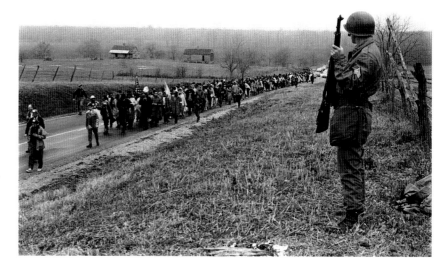

The March for Voting Rights from Selma to Montgomery makes its way through Lowndes County under the protection of US Army.

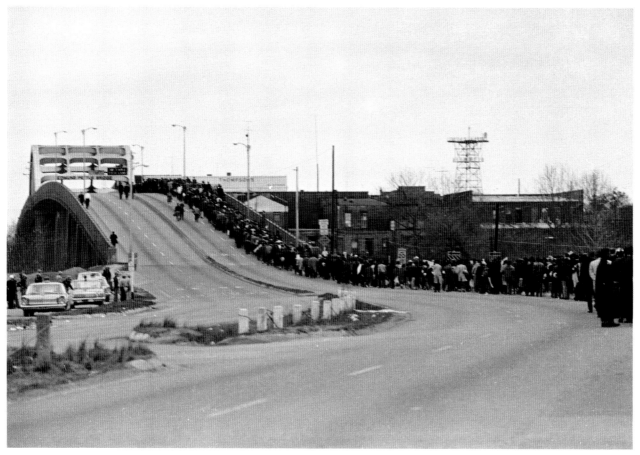

Marchers cross the Edmund Pettus Bridge and return to Selma on Turnaround Tuesday.

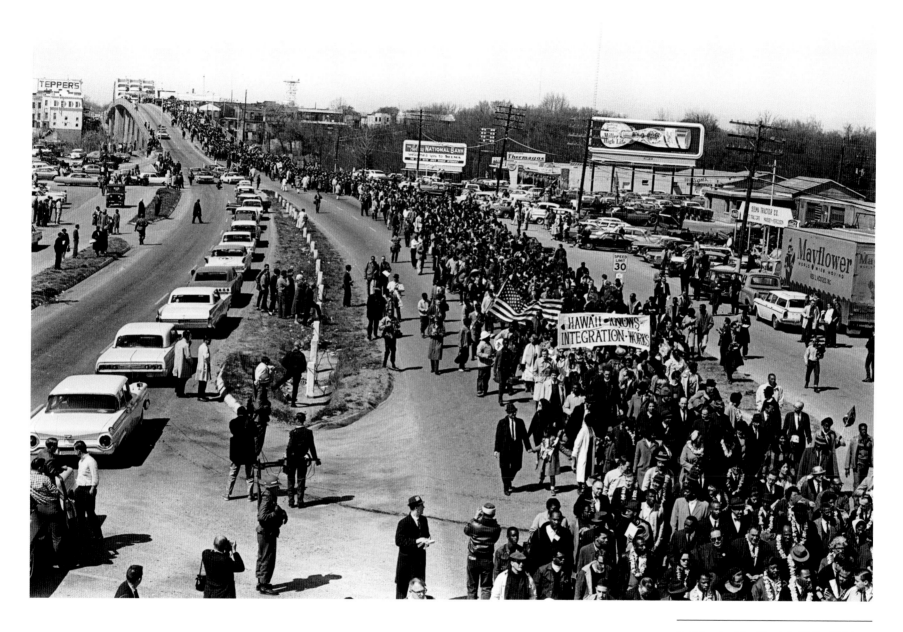

Participants of the March for Voting Rights third march making its way over the Edmund Pettus Bridge.

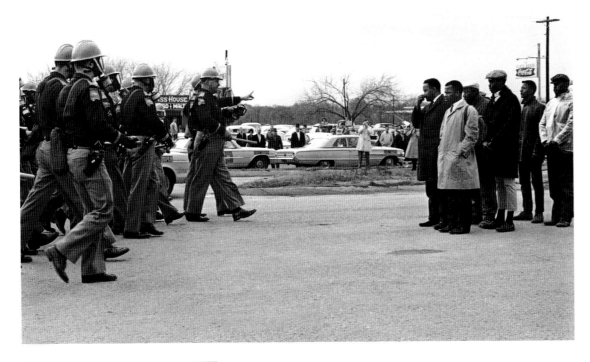

Rev. Hosea Williams, John Lewis, and others
in the March for Voting Rights to Montgomery
confronted by Alabama state troopers.

Alabama state trooper beating John Lewis as
other marchers run back towards the Edmund
Pettus Bridge.

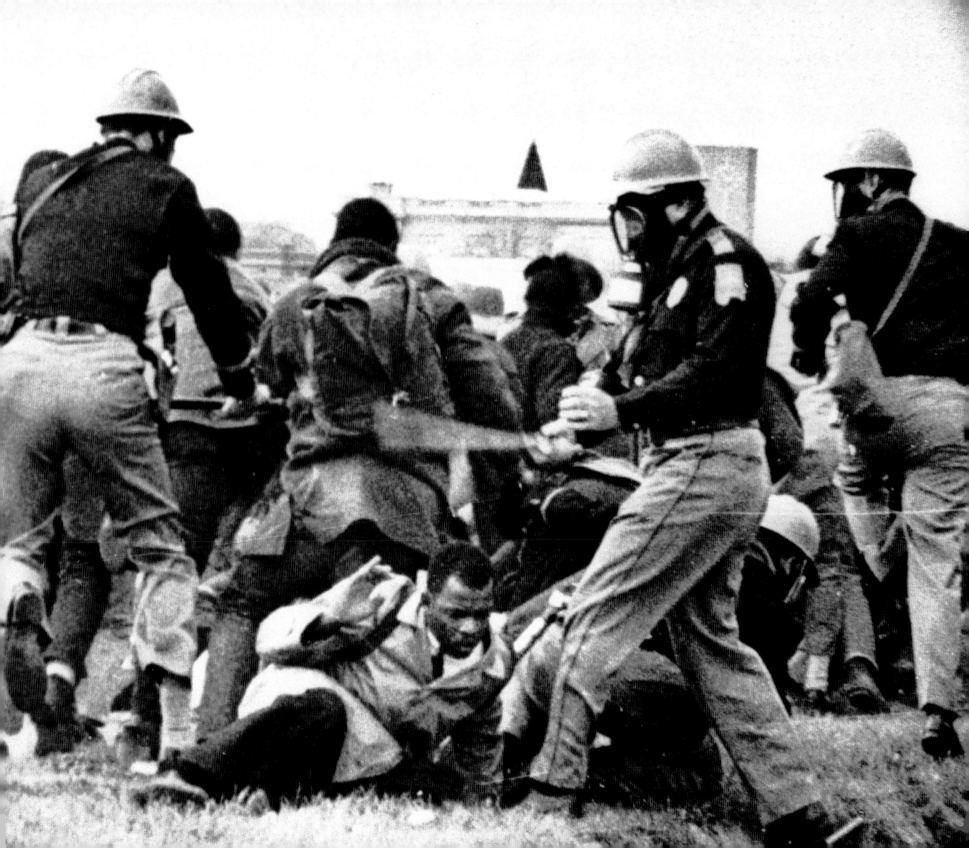

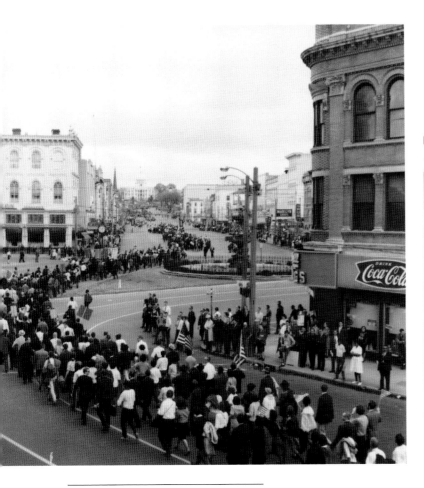

Looking down and from behind at marchers as they wind around a traffic island and up the road with the state capitol in the distance.

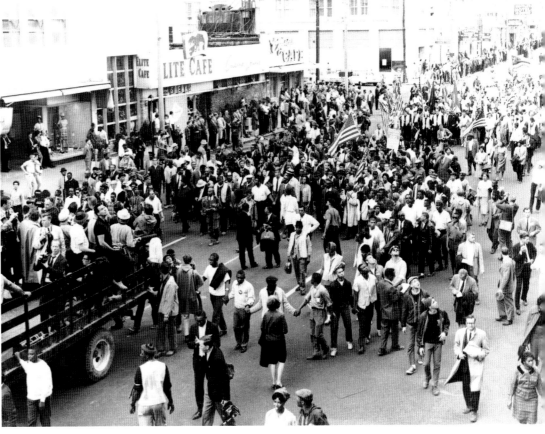

View looking down upon the Selma march preceded by a truck of press men as they march toward the state capitol in Montgomery.

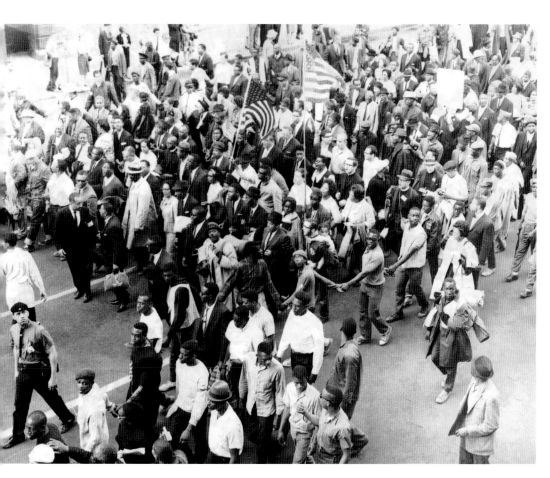

View looking down upon the civil rights leaders at the front of the Selma march as they march toward the state capitol in Montgomery.

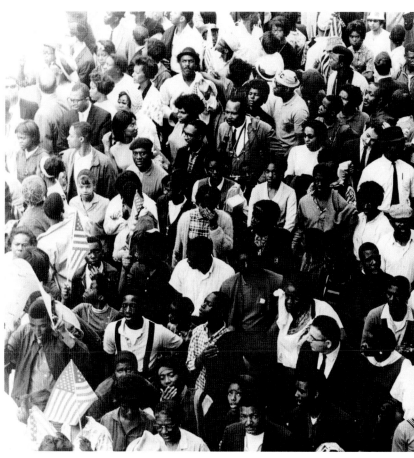

Closeup view looking down on Selma marchers as they march toward the state capitol in Montgomery.

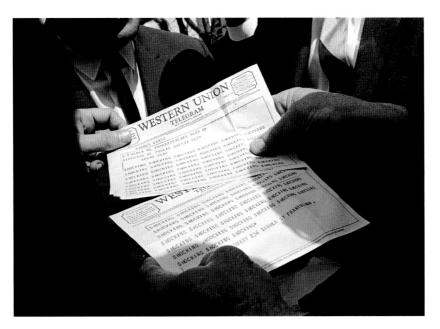

Selma's Wilson Baker receives a telegram
reacting to news of the Bloody Sunday events.

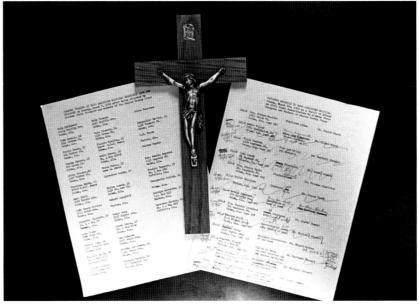

Flyers list civil rights activists injured by
Alabama state troopers on "Bloody Sunday."

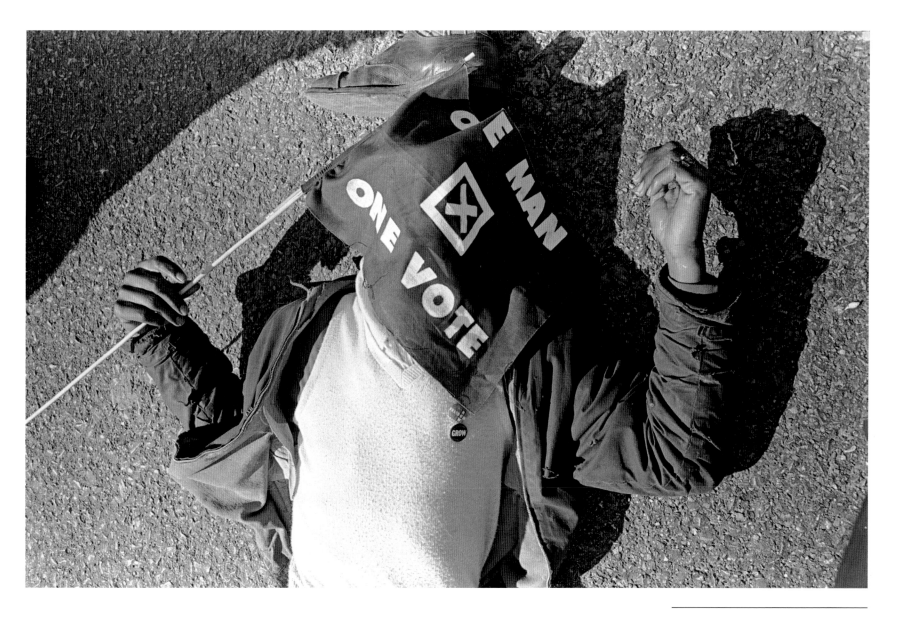

A voting rights demonstrator rests during the march to Montgomery.

1966

James Meredith March Against Fear, Jackson, MS

In 1966, James Meredith began a solo 220-mile "March Against Fear" from Memphis, Tennessee, to Jackson, Mississippi. The purpose of his march was to focus on racism in the American South and to encourage voter registration. He did not invite major civil rights organizations to join him. On the second day of his march, Meredith was shot by a white gunman. While Meredith was recovering in a hospital, his march drew civil rights advocates from around the nation. Meredith rejoined a group of fifteen thousand marchers when they reached Jackson on June 26. During the march, over four thousand African Americans registered to vote.

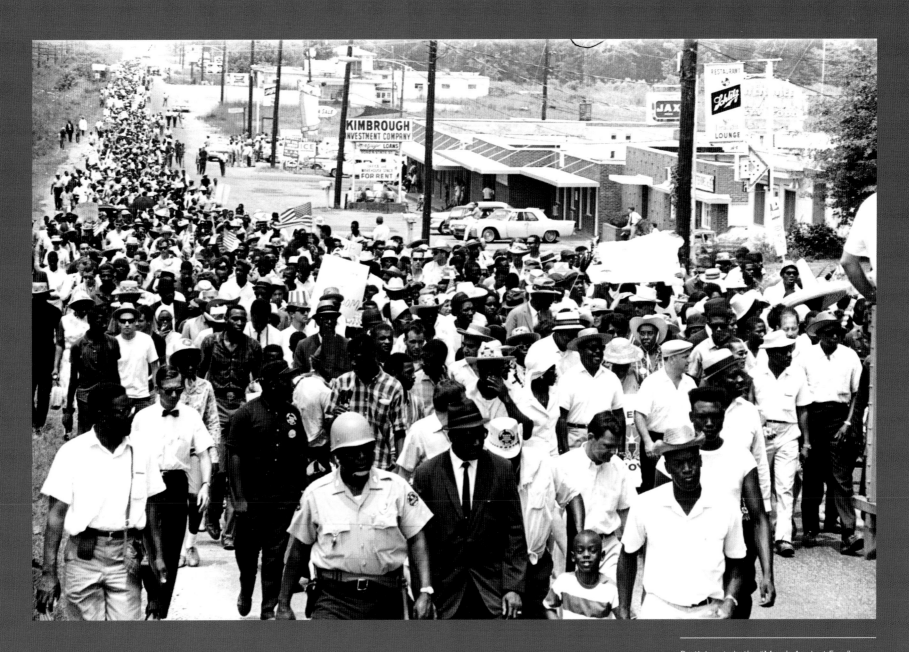

Participants in the "March Against Fear" begun by James Meredith, walking down North State Street in Jackson, Mississippi.

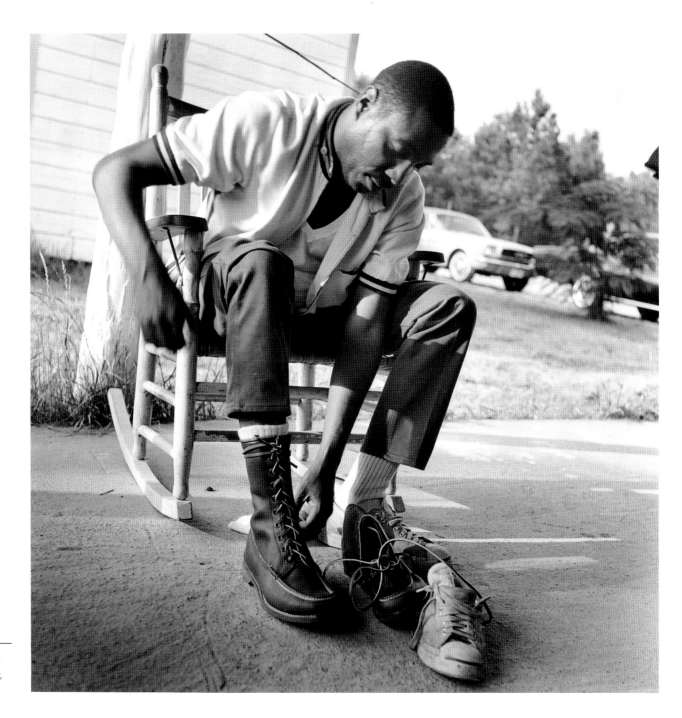

Dick Gregory on porch of James Meredith's family home during the March Against Fear, Kosciusko, Mississippi.

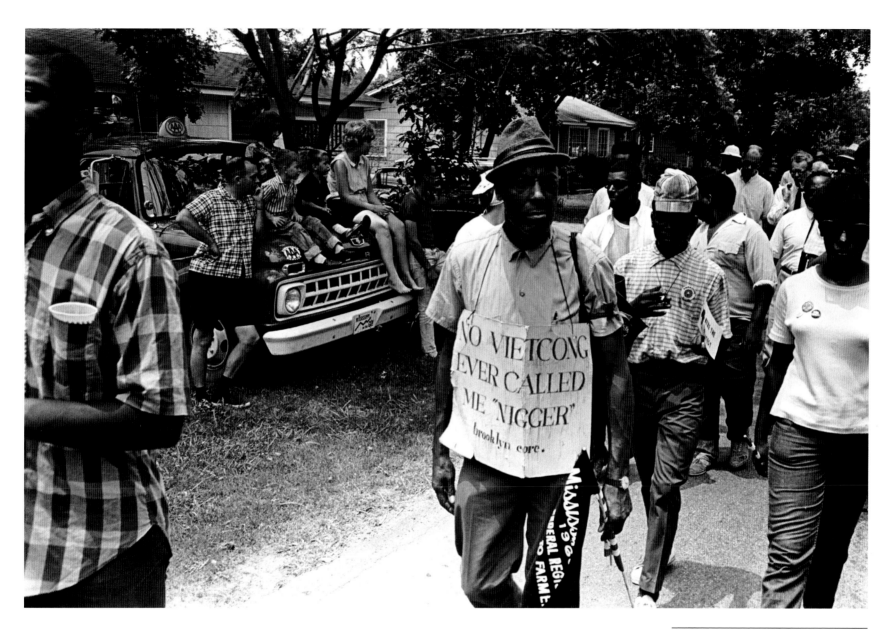

Participants in the "March Against Fear" begun by James Meredith, walking down the street of a neighborhood, Mississippi.

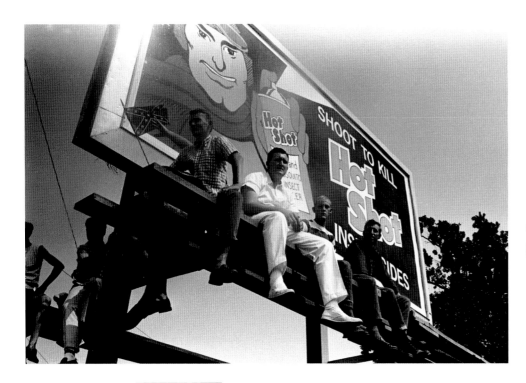

Four white men sitting on the platform in front of a billboard, observing the "March Against Fear" through Mississippi.

White boys on the side of a street during the "March Against Fear" begun by James Meredith.

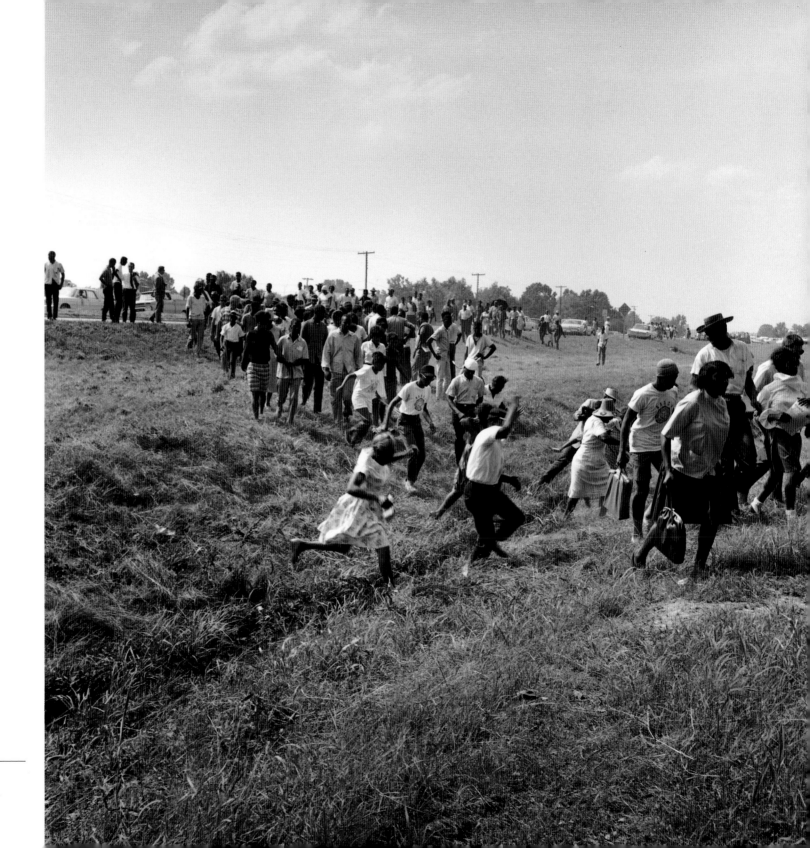

March Against Fear,
Coldwater, Mississippi.

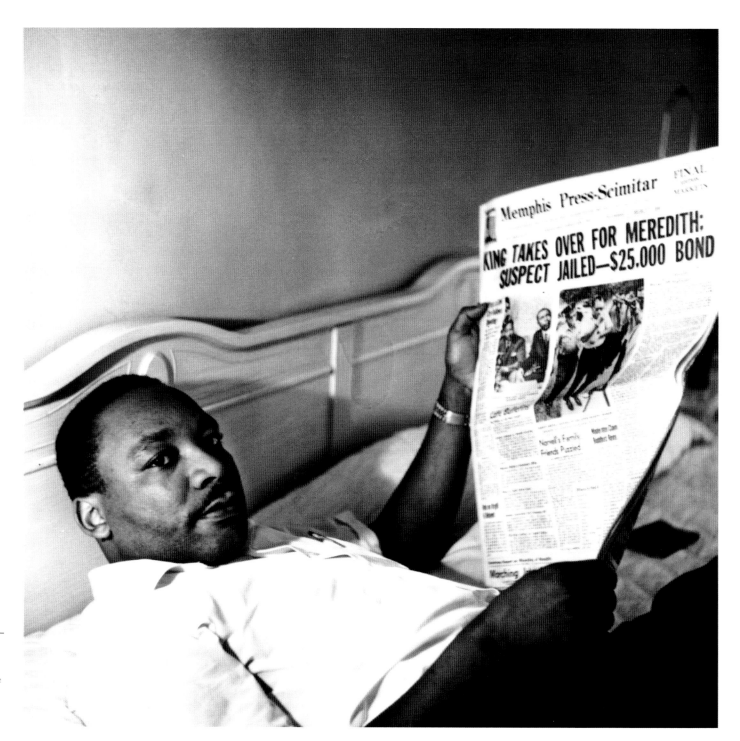

Dr. Martin Luther King Jr. resting reading the *Memphis Press-Scimitar* in the Lorraine Motel following the March Against Fear, Memphis, Tennessee.

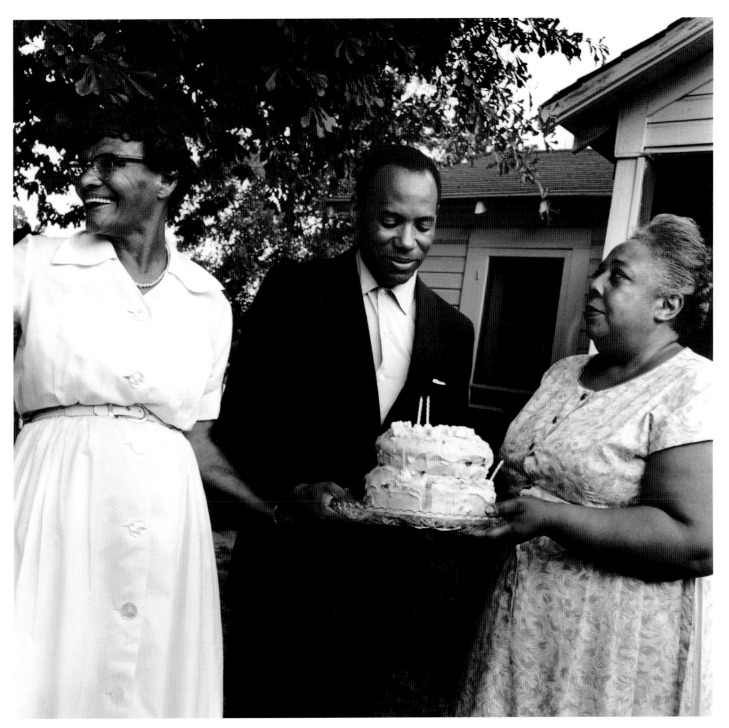

James Meredith returns home
after being shot, Kosciusko,
Mississippi, 1968.

1968

Mule Train–Poor People's March on Washington, Marks, MS

The Poor People's March on Washington was organized by Martin Luther King Jr. and the Southern Christian Leadership Conference to seek economic justice for poor people in the United States. Ralph Abernethy assumed leadership of the campaign after the assassination of Reverend King. In May 1988, three thousand protesters came from throughout the nation and set up a camp on the Washington Mall, where they lived for six weeks.

In planning the march, King said, "We ought to come in mule carts," and identified Marks, Mississippi, as the poorest town in the poorest state, where mule-drawn wagons would bring poor people to Washington. Inspired by King's wish, the "Mule Train" was a small part of the larger Poor People's March on Washington. On May 13, 1968, a caravan of fifteen mule-drawn wagons carrying a hundred protestors began their highly publicized trip and arrived in Washington on June 15, 1968. There they joined 2,900 other poor people and lived in tents and hand-built structures on the National Mall that were known as "Resurrection City" until their permit expired on June 23, 1968.

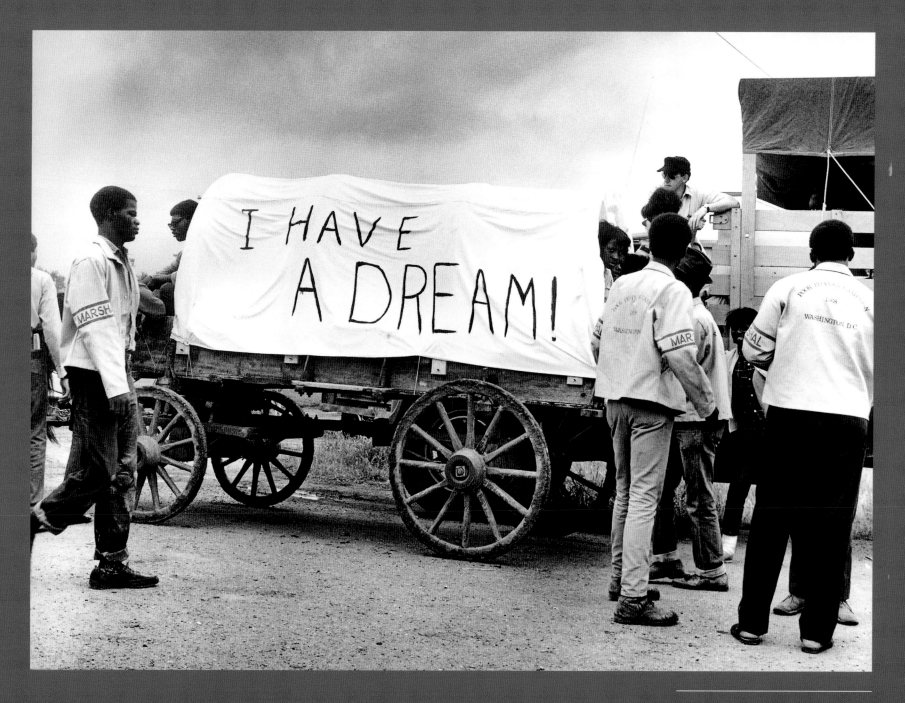

Mule train leaves for Washington, Poor People's March, Marks, Mississippi.

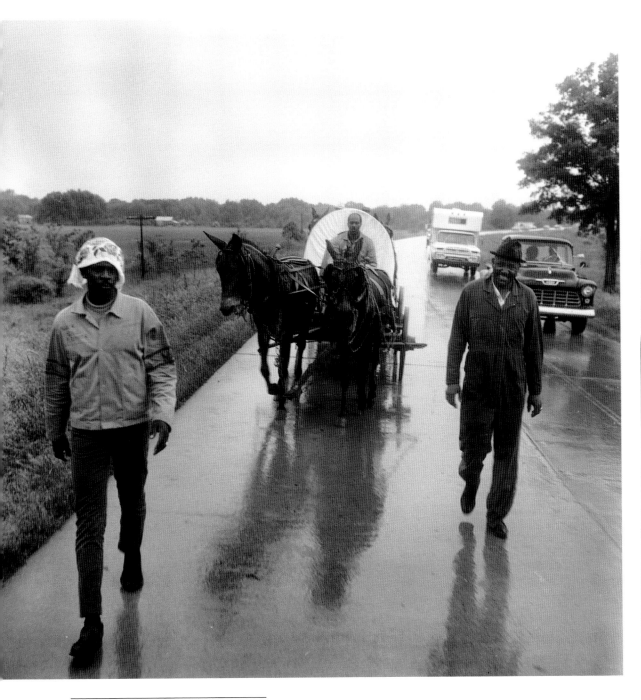

Mule Train, Marks, Mississippi.

Mule Train—Poor People's March, Marks, Mississippi.

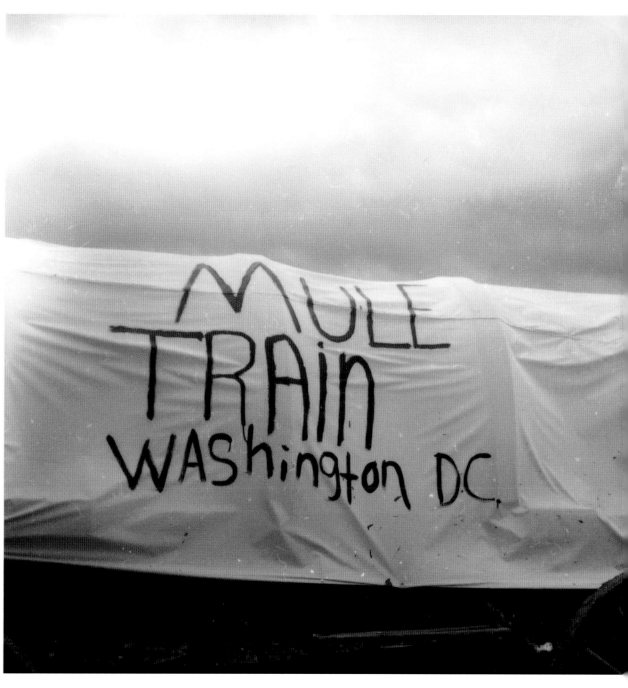

Mule Train—Poor People's March, Marks,
Mississippi.

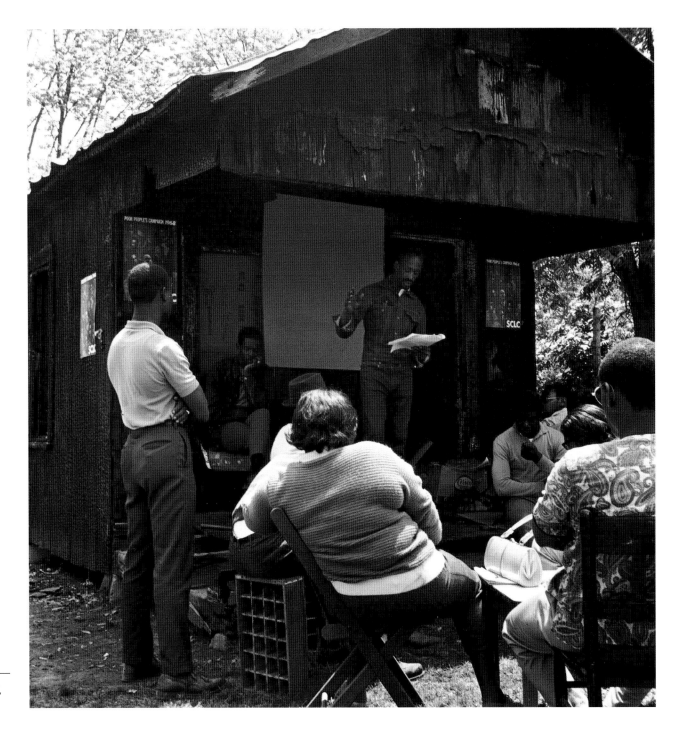

Poor Peoples Campaign, Marks, Mississippi, 1968. SCLC staff training for march to DC.

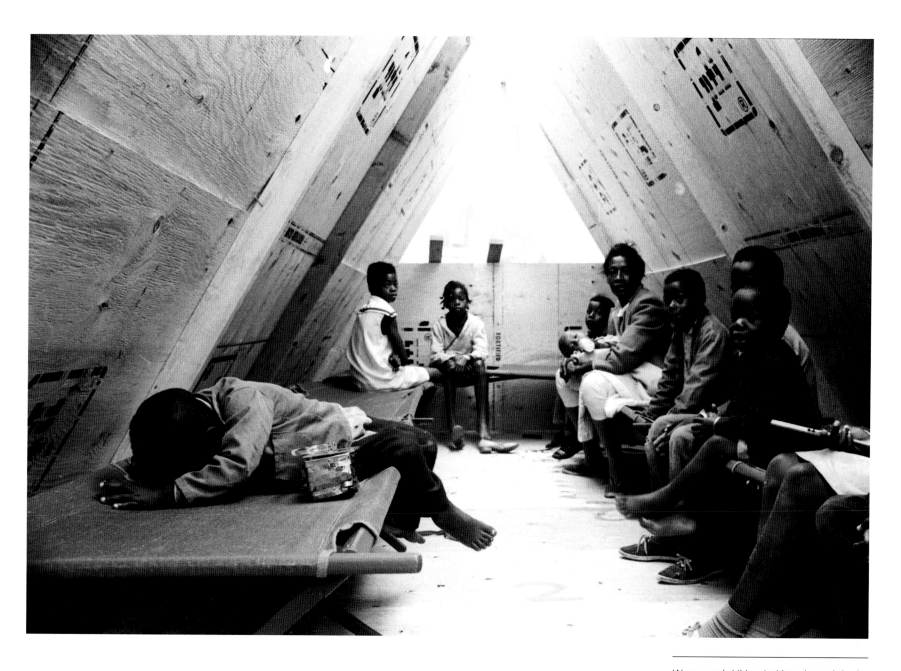

Woman and children inside a plywood shack
in Resurrection City during the Poor People's
Campaign, Washington, DC.

1968

Sanitation Workers Strike, Memphis, TN

The Memphis Sanitation Strike was launched on February 11, 1968, to protest the poor pay and dangerous working conditions of black workers after Echol Cole and Robert Walker were crushed to death in a garbage compactor. Reverend James Lawson's message to the strikers, "For at the heart of racism is the idea that a man is not a man," inspired the protestors' placards "I AM A MAN."

On April 4, 1968, the day after his "I've Been to the Mountaintop" speech at the Mason Temple, Reverend Martin Luther King was assassinated at the Lorraine Motel in Memphis. On April 8 Coretta Scott King marched silently with forty-two thousand participants in Memphis, and the strike ended on April 16 with the city's recognition of the strikers' union and wage increases. The strike was a turning point for civil rights and union activity in Memphis.

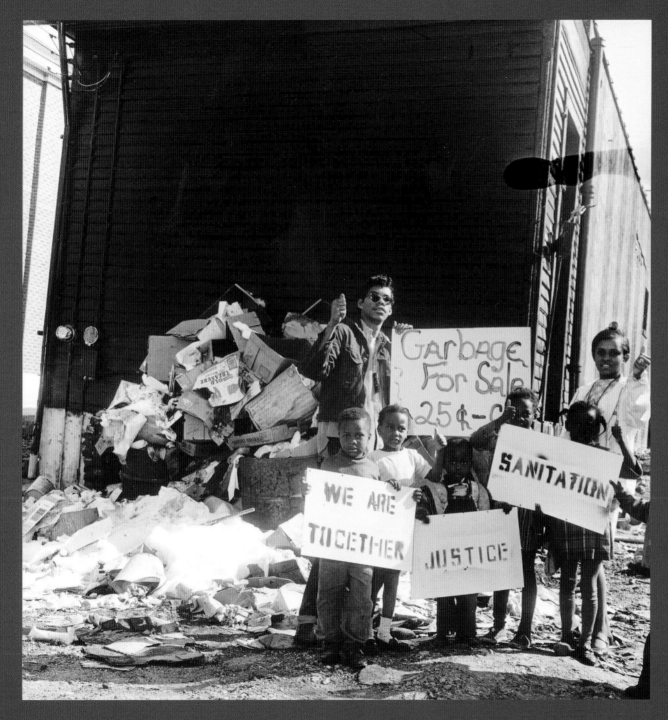

Children pose in front of garbage during sanitation workers' strike, Memphis, Tennessee, March 1968. Signs read, "Garbage for Sale" and "Justice."

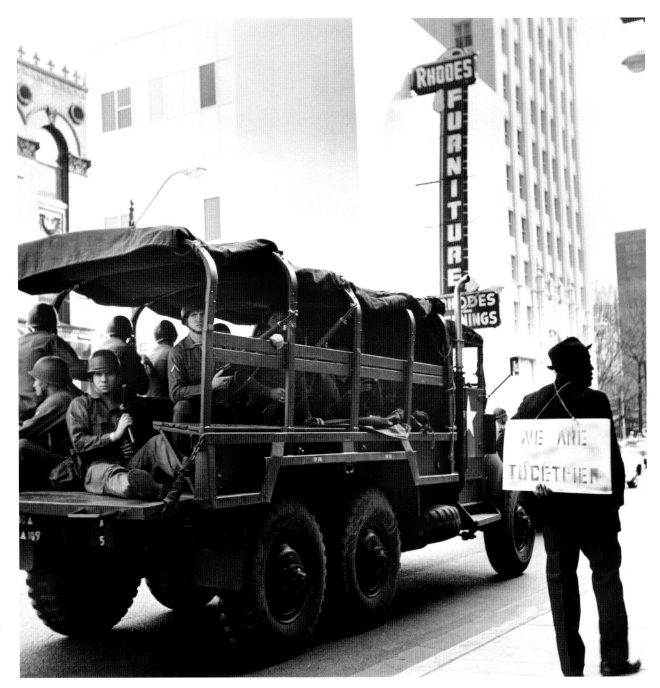

Downtown Main Street, Memphis, Tennessee,
March 1968, during sanitation workers' strike.
Sign reads, "We are together."

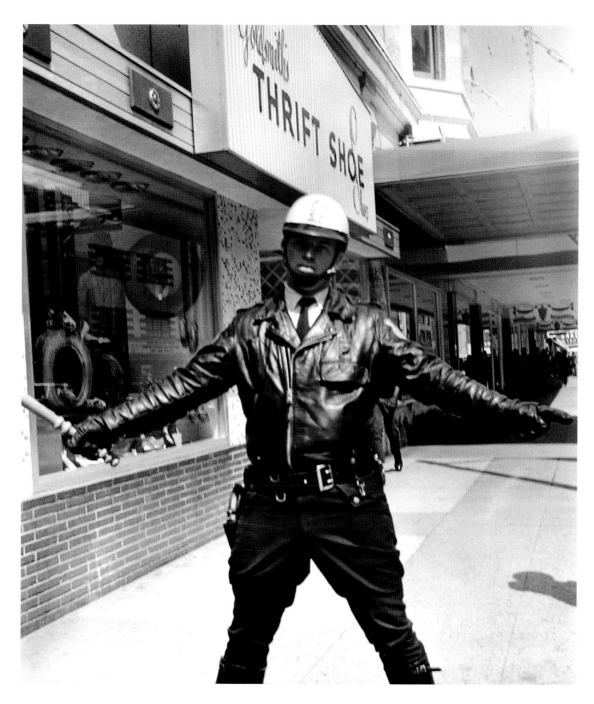

Sanitation workers' march is stopped on
Main Street, Memphis, Tennessee.

1968

Martin Luther King Jr. Assassination, Memphis, TN

On April 4, 1968, Martin Luther King Jr. was shot while standing on the second-floor balcony of the Lorraine Motel in Memphis, Tennessee. Ralph Abernethy, Jesse Jackson, and Andrew Young were with Dr. King when he was taken to St. Joseph's Hospital, where he died.

His assassin, James Earl Ray, was arrested on June 8, 1968, in London at Heathrow Airport, extradited to the United States, and sentenced to ninety-nine years in the Tennessee State Penitentiary, where he died on April 23, 1998, at the age of seventy.

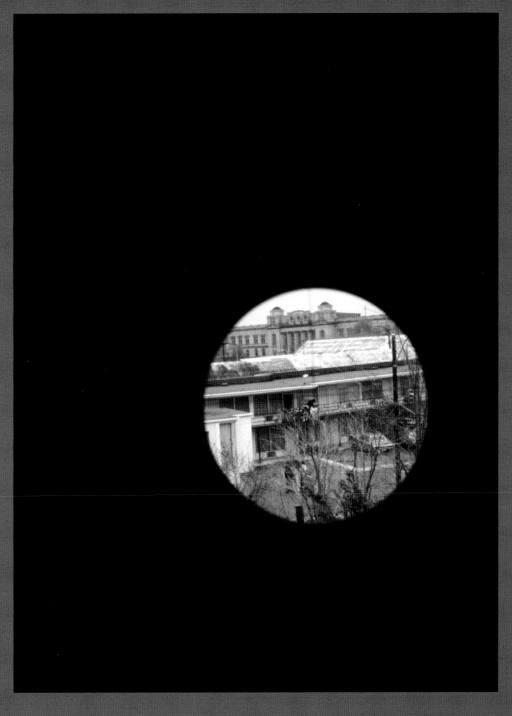

View of the Lorraine Motel from James Earl
Ray's vantage in boarding house.

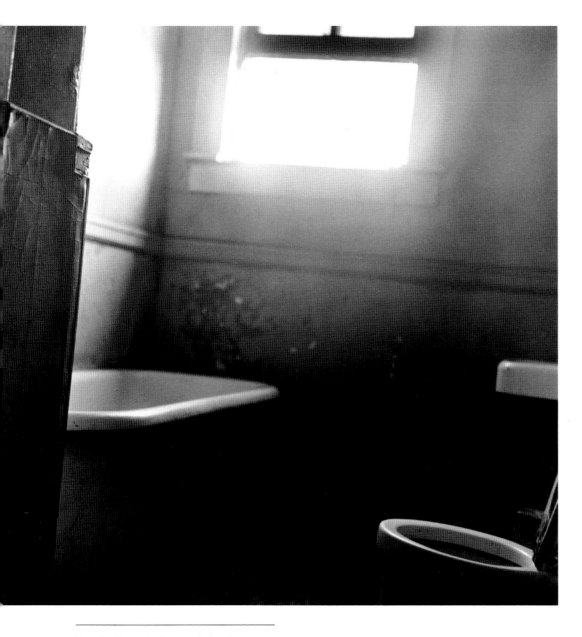

Boarding house bathroom window from
which James Earl Ray shot and killed Dr. King.
422 South Main Street, Memphis.

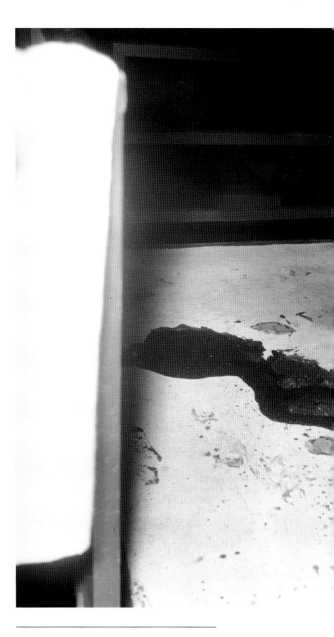

MLK's blood on balcony of Lorraine Motel.

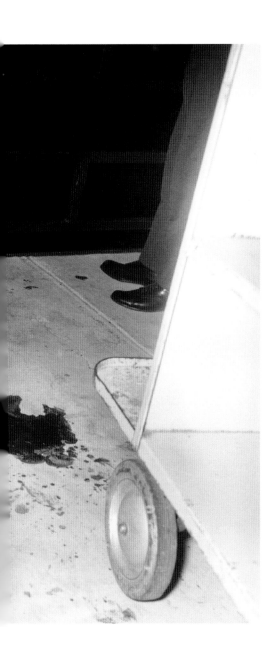
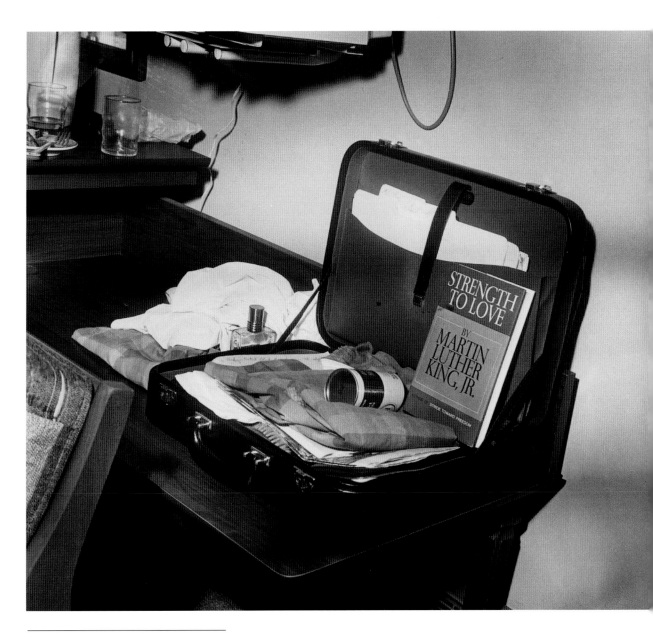

Briefcase of Dr. King, room 306, Lorraine
Motel, following his assassination.

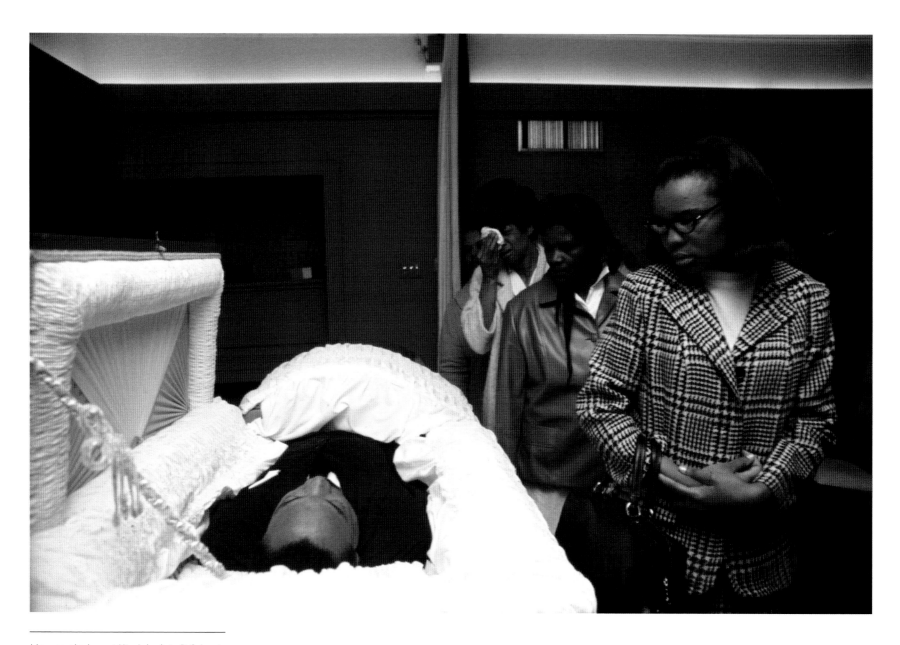

Mourners look on at King's body in R. S. Lewis
Funeral Home.

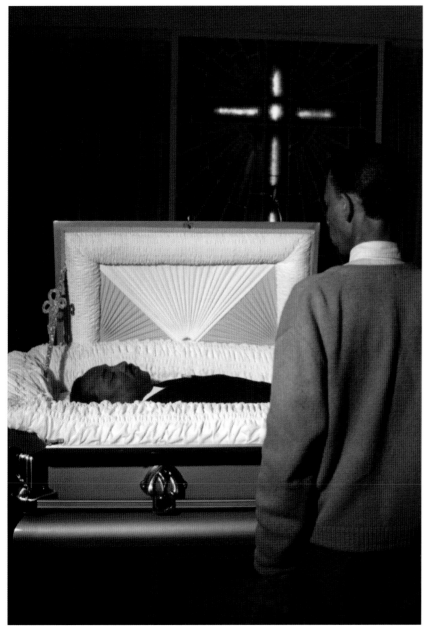

Mourner looks on at King's body in R. S. Lewis Funeral Home.

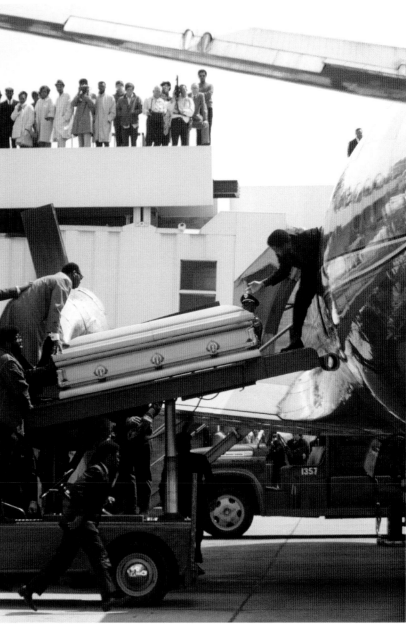

Dr. King's coffin loaded onto a plane to Atlanta.

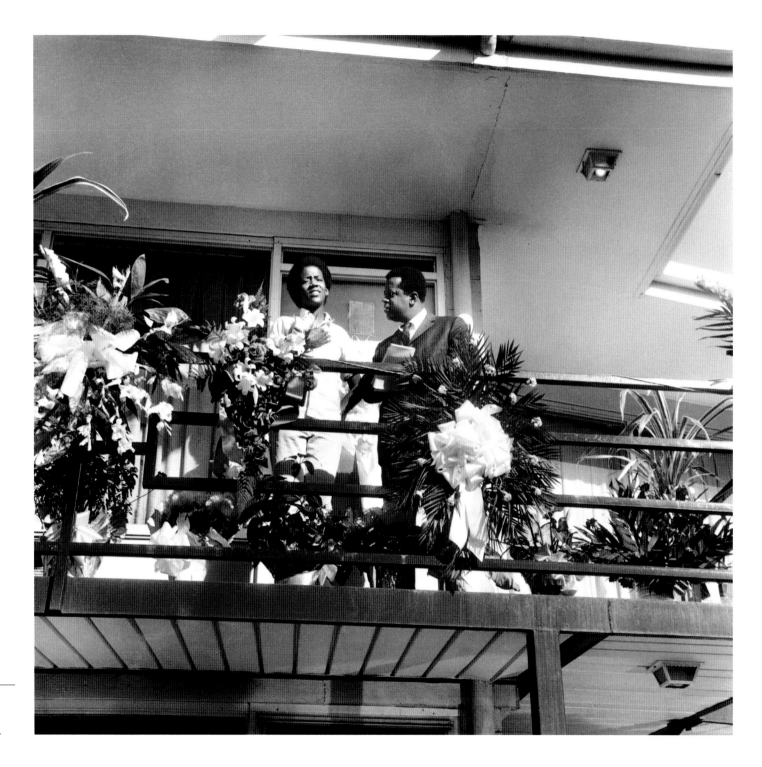

On the balcony of the
Lorraine Motel following
the assassination of MLK.

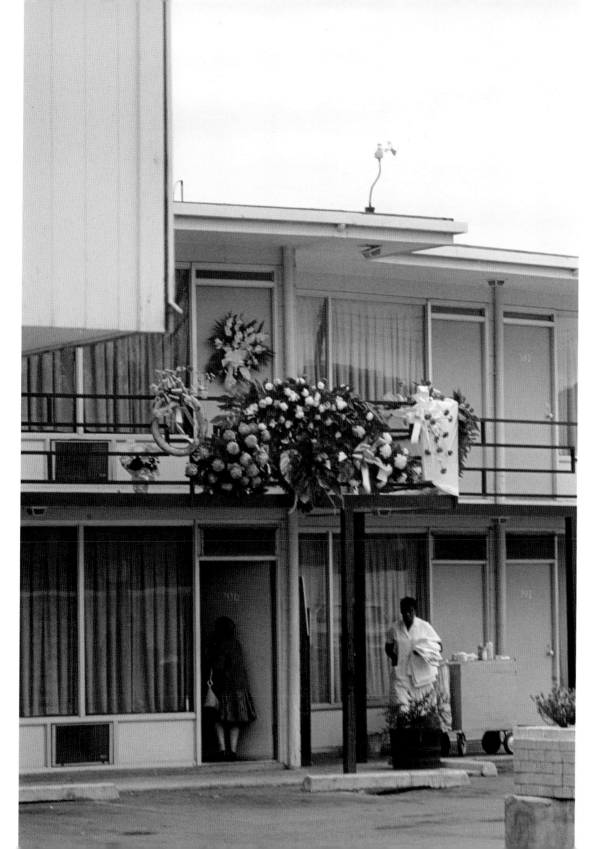

Wreaths and flowers left as memorials to
Dr. King at the Lorraine Motel.

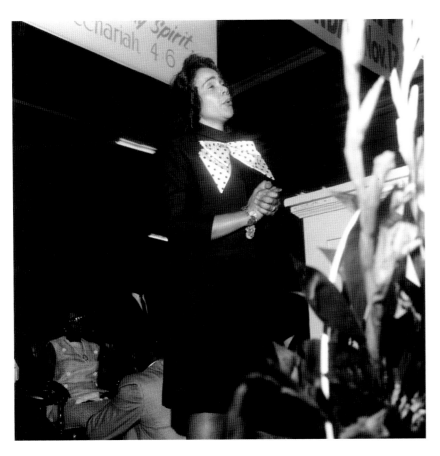

Coretta Scott King at Mason Temple, speaking at same podium from which Dr. King made his last speech, Memphis, Tennessee.

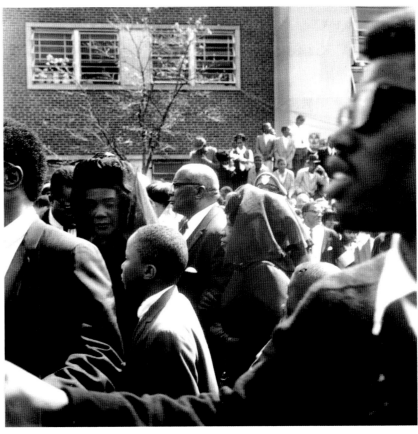

Coretta Scott King and Martin Luther King Sr. in Dr. King's funeral procession, Atlanta, Georgia, April 1968. Young boy is MLK III, with Bernard Lee behind Coretta Scott King.

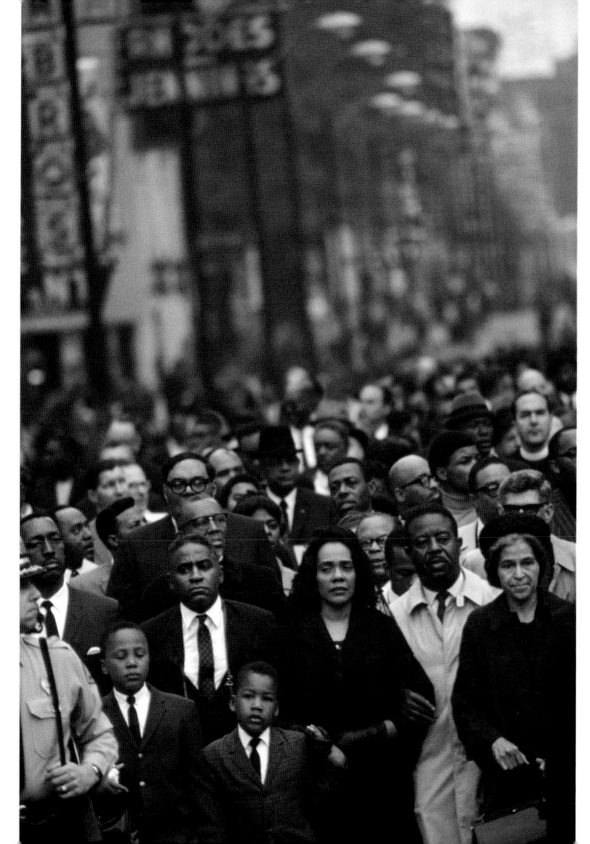

Coretta Scott King and Rosa Parks march following King's assassination, Memphis, Tennessee.

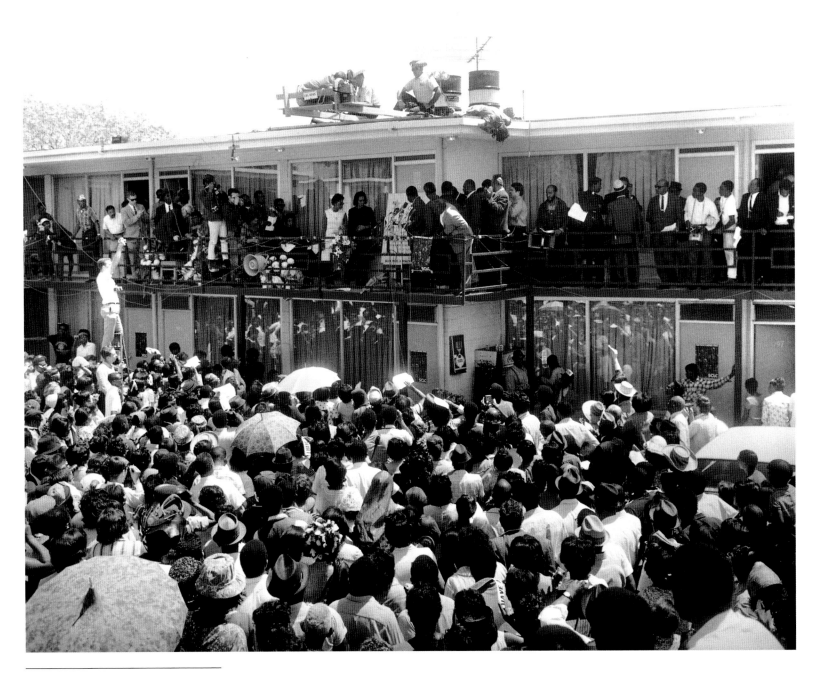

Crowd outside Lorraine Motel after the
assassination of Dr. King.

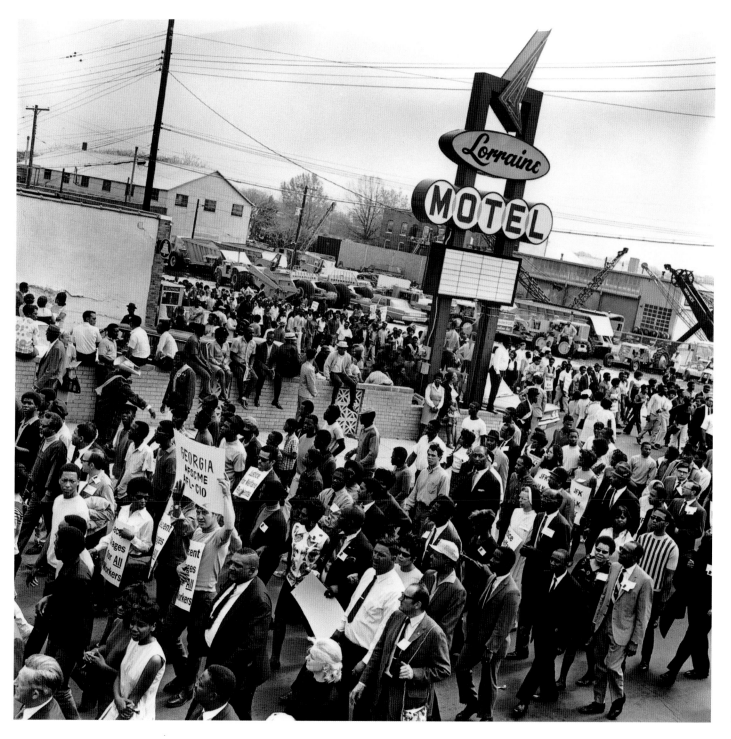

Marchers at entrance of
the Lorraine Motel after the
assassination of Dr. King.

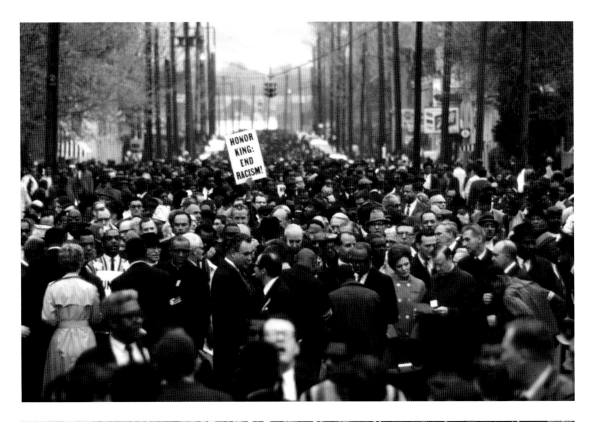

Mourners following Dr. King's assassination, a single sign held aloft, Memphis, Tennessee.

Mourning crowd following Dr. King's assassination, Memphis, Tennessee.

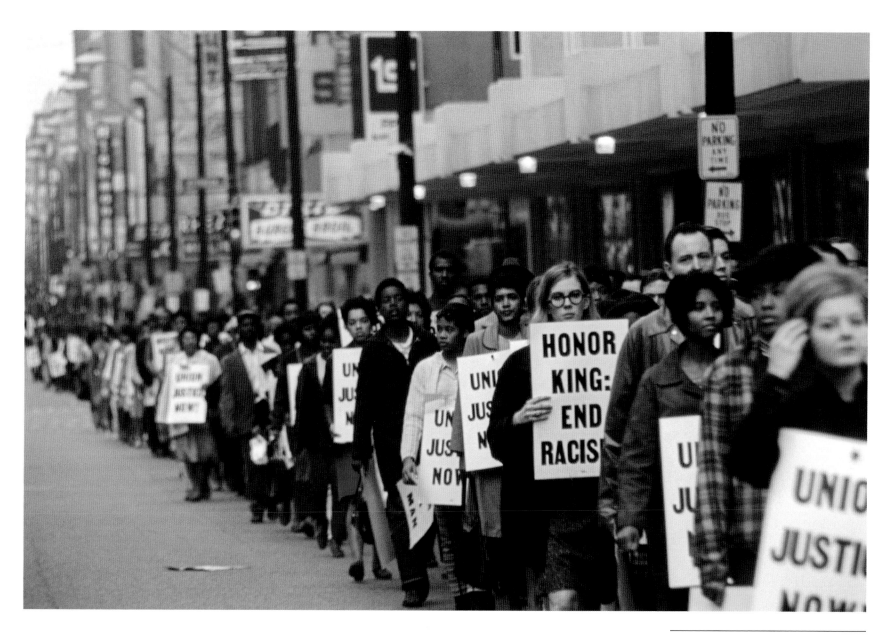

Mourners and demonstrators, carrying signs, line up in the street, Memphis, Tennessee.

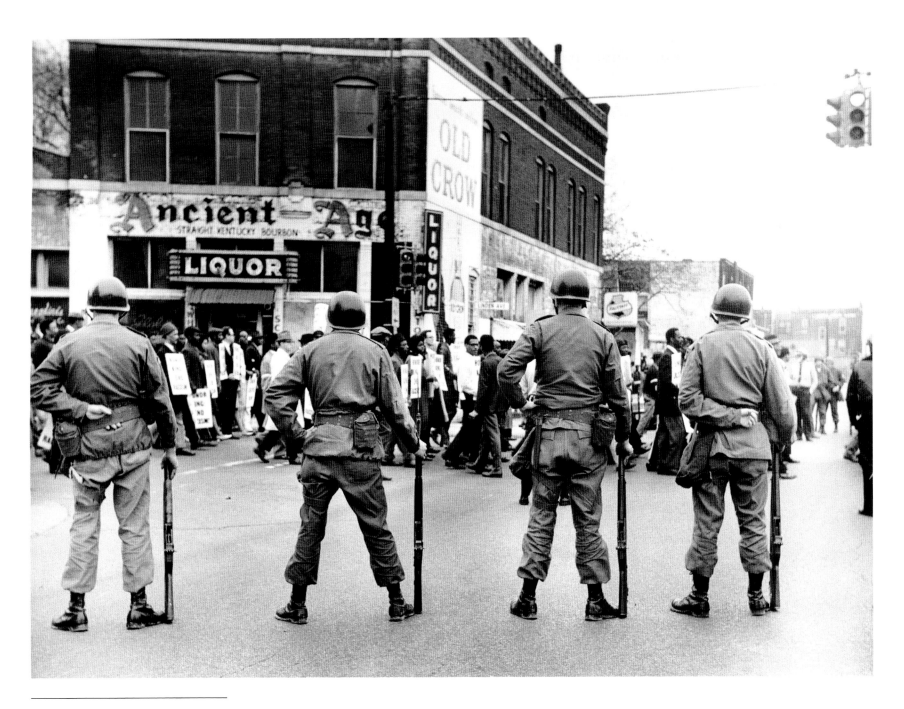

National Guard at Main and Linden Street
after the assassination of Dr. King, Memphis,
Tennessee.

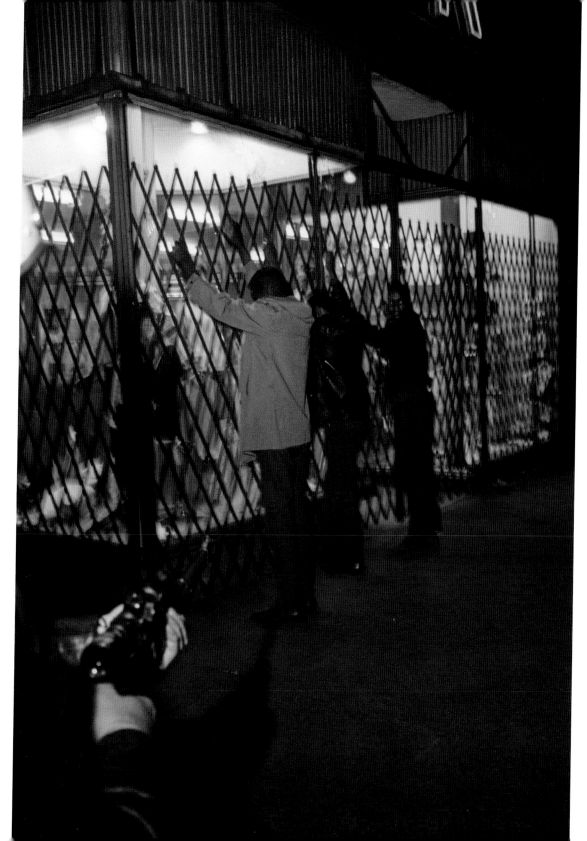

Searching for Dr. King's killer, Memphis, Tennessee.

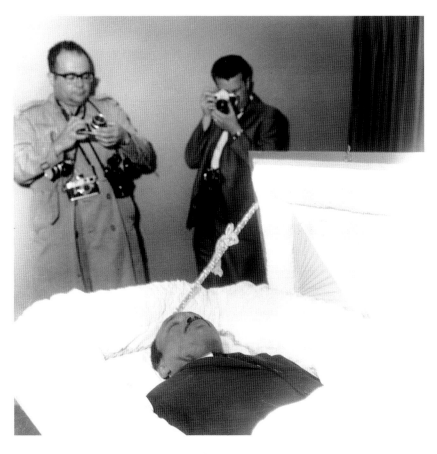

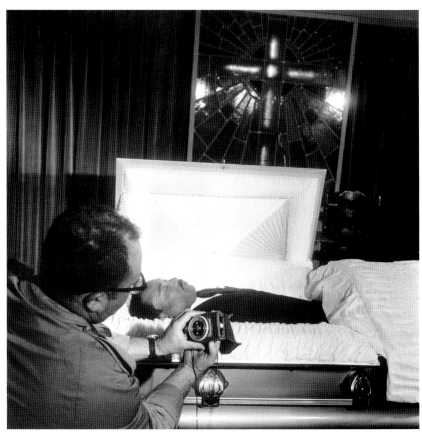

Photographers over Dr. King's casket,
Memphis, Tennessee.

Dr. Martin Luther King Jr. in casket at
R. S. Lewis funeral home. Journalist is
Maurice Sorrell, photographer for *Jet*,
Memphis, Tennessee.

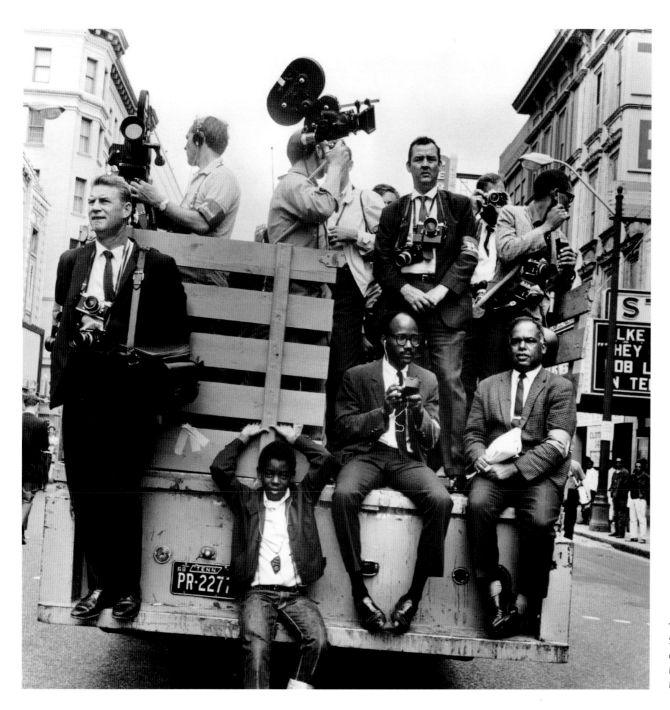

Son of Rev. Ralph Abernathy rides on the back of press truck after assassination of Dr. King, Memphis, Tennessee. Nick Taylor with wire, Memphis talk show.

1970

Jackson State University

The decade of 1960–1970 tragically ended in Jackson, Mississippi, on the campus of Jackson State University, where two students, Phillip Lafayette Gibbs, a junior at Jackson State, and James Earl Green, a senior at Jim Hill High School, were killed, and twelve other students were wounded by Jackson police on May 14, 1970. Photographer Doris Derby worked at Jackson State at the Margaret Walker Center and also taught in the Art Department at the time of the shooting. Derby was also on the staff of SNCC's Poor People's Corporation and Southern Media Inc., a documentary photography and filmmaking unit. She photographed the funeral procession for Gibbs and Green as it passed Alexander Hall, where the shooting occurred.

Derby recalled that, as the hearse drove by, students with raised fists "were guarding the building because they did not want officials to clean the crime scene. They were waiting for the FBI to examine the evidence. They had laid wreaths of flowers in memory of the two students killed and the twelve students injured." Derby also photographed Mayor Charles Evers, Congressman Adam Clayton Powell Jr., and Congressman Edward W. Brooke III, when they met in Jackson with the President's Commission on Campus Unrest to investigate the shootings.

Gibbs Green student hearings, Masonic
Temple, Jackson, Mississippi, 1970.

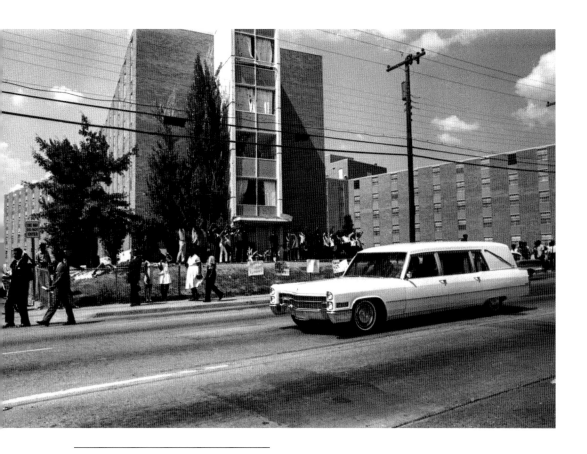

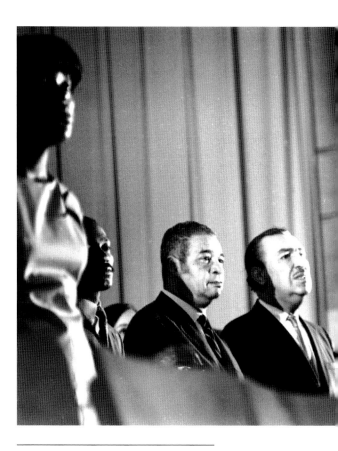

James Green's funeral procession, Lynch
Street, Jackson, Mississippi, 1970.

Dignitaries at James Green's funeral, Masonic
Temple, Jackson, Mississippi, 1970.

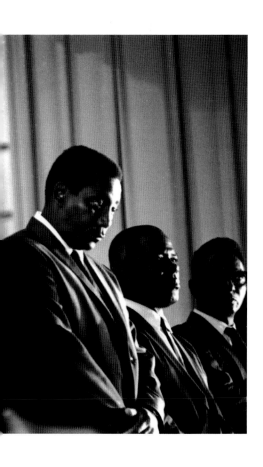

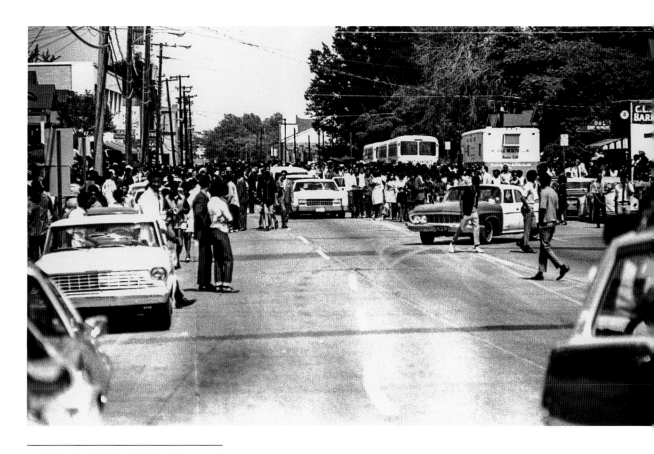

James Green's funeral procession, Lynch
Street, Jackson, Mississippi, 1970.

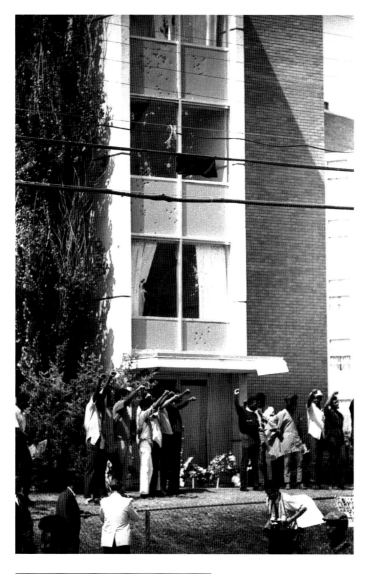

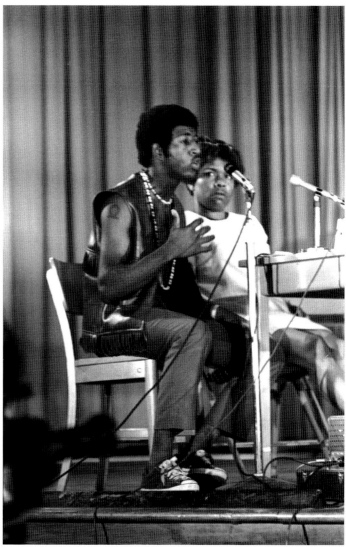

Alexander Hall protestors of Gibbs Green
murder, Jackson State University, Jackson,
Mississippi, 1970.

Gibbs Green murder hearings, JSU student
and Attorney Constance Slaughter Harvey,
Jackson, Mississippi, 1970.

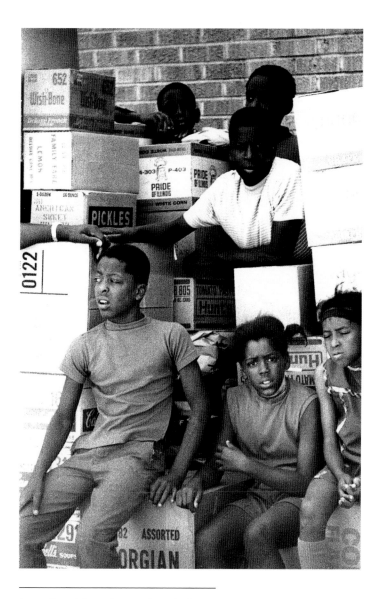

James Green's funeral procession onlookers,
Lynch Street, Jackson, Mississippi, 1970.

PHOTOGRAPHER BIOGRAPHIES

Norman Dean (b. 1944)

As a staff photographer for the *Birmingham News*, Norman Dean covered civil rights demonstrations and counter-protests in Alabama. In 2009, Dean and eleven other photographers who covered the civil rights movement for the *Birmingham News* in the 1950s and 1960s were recognized by the Anti-Defamation League at the group's annual Concert Against Hate at the John F. Kennedy Center for the Performing Arts in Washington.

Doris Derby (b. 1939)

Doris Derby served as a field secretary for the Student Nonviolent Coordinating Committee. In that position, Derby photographed farmers, textile workers, doctors, and teachers. She connected their struggle for food security, fair workplace conditions, and access to health services with civil rights actions that took place in the public eye. At Georgia State University, Derby enjoyed a long career as a professor of anthropology, and in 2011 she was awarded the Georgia Humanities Award.

Bruce Hilton (1930–2008)

The Reverend Bruce Hilton and his wife Virginia moved their family to Greenville, Mississippi, in 1965, where he worked with Owen Brooks at the Delta Ministry. Hilton was a journalist and a United Methodist minister who led voter registration campaigns in the Mississippi Delta where he, his wife, and their children helped register seventy thousand new black voters and trained black candidates to run for political office. While living in Greenville, the family found a bullet hole in their living room window one night and were later evicted after the Ku Klux Klan spread rumors that the couple were communists.

Warren Leffler (1926–2014)

During his career with *US News & World Report* in Washington, DC, Warren Leffler photographed many of the political events during the 1960s and '70s, including protests, riots, elections, and diplomatic visits. Leffler's work captures critical developments in American politics, and his images reflect both the gravity and scale of the events he photographed and the warmth and humanity of his subjects.

Spider Martin (1939–2003)

As a young photographer for the *Birmingham News*, James "Spider" Martin was assigned to cover the murder of Jimmie Lee Jackson, a deacon who was shot by Alabama State Trooper James Fowler. This event sparked the Selma to Montgomery March and placed Spider Martin at the center of Martin Luther King's movement in Alabama. Dr.

King credited Martin's photographs for publicizing the movement and advancing its cause. Martin's photographs have been published in both American and international publications, cementing his legacy as one of the most important documentarians of the civil rights movement.

Calvert McCann (1942–2014)

A chronicler of the struggle for civil rights in Kentucky, Calvert McCann worked as a teenager in a photography store when he first documented the civil rights movement in Lexington and Frankfort. Because these events were not covered by local news organizations, it was assumed that no visual record of Kentucky's civil rights movement existed. Encouraged by a University of Kentucky professor forty years later, McCann developed his film and created the only photographic record of the civil rights movement in Lexington.

Wilfred Moncrief (1923–2000)

A Mississippi photojournalist, Winifred Moncrief was the chief photographer of the *Hattiesburg American*, and he covered Ku Klux Klan rallies and civil rights demonstrations. In addition to freelancing for publications such as *Time* and *Life*, Moncrief taught photography and journalism at Gulf Park College in Long Beach, Mississippi, and at Mississippi Gulf Coast Community College at its Perkinston and Jefferson Davis campuses.

Jim Peppler (b. 1941)

A native of Philadelphia, Pennsylvania, Jim Peppler was a staff photographer for the *Southern Courier*, a Montgomery, Alabama, newspaper dedicated to investigating and analyzing race relations in the United States. Peppler covered the civil rights movement from July 1965 to mid-1968. During his three years working for the *Southern Courier*, he took over eleven thousand photographs that document the civil rights movement, social conditions in central Alabama, the nightclub Laicos in Montgomery, and the funeral of Martin Luther King Jr. After leaving the *Southern Courier*, he worked with *Newsday*, and he now teaches at both Adelphi and Stony Brook Universities.

Bruce Roberts (b. 1930)

As a member of the *Charlotte Observer*'s pioneering photojournalism staff in the 1960s, Bruce Roberts has had a long career as a photographer of the American South. Working for publications such as *Time*, *Life*, *Sports Illustrated*, and *Southern Living*, Roberts has explored every facet of life in the South with care and compassion. For the past twenty years, he and his wife Cheryl have documented the coastal regions of North Carolina.

Art Shay (1922–2018)

Originally a staff writer for *Life*, Art Shay launched his career as a freelance photographer in Chicago, where he produced work for national publications. He documented postwar America, as well as influential politicians, artists, scientists, entertainers, and innovators of the twentieth century. In 2017, Shay received the Lifetime Achievement Award from the Lucie Foundation in recognition of his career as a master of his craft.

Don Sturkey (b. 1931)

As a photographer for the *Charlotte Observer*, Don Sturkey documented North Carolina worlds, including high school football games, election campaigns, concerts, and the Ku Klux Klan. He was inducted into the North Carolina Journalism Hall of Fame in 1991 in honor of his work as a journalist and documentarian

Ernest Withers (1922–2007)

Ernest Withers trained as a photographer in the US Army during World War II and is best known for his comprehensive documentation of black life in the American South. Withers's photographs capture an immense, detailed portrait of the black community in his native

Memphis. He traveled with Martin Luther King Jr. and photographed King both at public and private events. He also documented Memphis's music scene in the 1960s and '70s. His massive archive of over one million images is preserved and displayed at the Ernest Withers Museum and Collection in Memphis.

LIST OF REPRODUCED PHOTOGRAPHS

Cover and pages vii and 2
Sanitation workers assemble in front of Clayborn Temple for a solidarity march. "I Am A Man" was the theme for Community On the Move for Equality (C.O.M.E.), Memphis, Tennessee, 1968. Photo by Ernest Withers and courtesy of the Withers Collection. © Withers Collection, Inc.

Page 4
University of Kentucky student Nieta Dunn sitting in the all-white section at a dime store lunch counter, Lexington, Kentucky, 1960. Photo by Calvert McCann and courtesy of the University of Kentucky Archives. © Calvert McCann.

Page 5
Voter registration August 25, 1965; federal examiner C. A. Phillips administers voter registration oath to Joe Ella Moore, Prentiss, Mississippi, 1965. Photo by Wilfred Moncrief and courtesy of the Mississippi Department of Archives and History. © Moncrief Photograph Collection.

Page 6
Protester with sign reading "Jim Crow Will Be the Death of America Yet!" Farmville, Virginia, 1963. Photo by Wilfred Moncrief and courtesy of the Mississippi Department of Archives and History. © Moncrief Photograph Collection.

Page 6
Singer Mahalia Jackson at the Charlotte Coliseum, November 21, 1961. Photo by Don Sturkey and courtesy of the Wilson Library. © Don Sturkey.

Page 8
Charred remains of Vernon Dahmer's car the morning his house and store in the Kelly Settlement were firebombed on January 10, 1966. Photo courtesy of the Mississippi Department of Archives and History.

Page 11
Segregated waiting room in Memphis bus station. Photo by Ernest Withers and courtesy of the Withers Collection. © Withers Collection, Inc.

Page 12
Demonstrators marching past stores on Main Street, Lexington, Kentucky, 1960. Photo by Calvert McCann and courtesy of the University of Kentucky Archives. © Calvert McCann.

Page 13
Women at sit-in at a lunch counter, Lexington, Kentucky, 1960. Photo by Calvert McCann and courtesy of the University of Kentucky Archives. © Calvert McCann.

Page 14
Minister directs choir at SCLC convention rally at SME church. Photo by Ernest Withers and courtesy of the Withers Collection. © Withers Collection, Inc.

Page 14
Protesters attending a training session, Charlotte, North Carolina, 1960. Photo by Don Sturkey and courtesy of the Wilson Library. © Don Sturkey.

Page 15
African Americans and a few whites picket Charlotte department stores, woman with sunglasses and holding a sign looking into the camera, 1960. Photo by Don Sturkey and courtesy of the Wilson Library. © Don Sturkey.

Page 15
African Americans and a few whites picket Charlotte department stores, elderly woman wearing a sash, 1960. Photo by Don Sturkey and courtesy of the Wilson Library. © Don Sturkey.

Page 16
Protester with sign reading "Brotherhood or Klanhood?" Farmville, Virginia, 1963. Photo courtesy of Virginia Commonwealth University.

Page 16
Protester with sign reading "Discrimination Anywhere Is Everybody's Business." Farmville, Virginia, 1963. Photo courtesy of Virginia Commonwealth University.

Page 16
Protester with sign reading "Mob Terror? or Police Protection." Farmville, Virginia, 1963. Photo courtesy of Virginia Commonwealth University.

Page 16
Protester with sign reading "There Is No Equal Protection Under Law for Colored People Here." Farmville, Virginia, 1963. Photo courtesy of Virginia Commonwealth University.

Page 17
William Edwin Jones pushes daughter Renee Andrewnetta Jones (eight months old) during protest march on Main Street, Memphis, Tennessee, August 1961. Photo by Ernest Withers and courtesy of the Withers Collection. © Withers Collection, Inc.

Page 18
Lynching victim lying on morgue table, Clarksdale, Mississippi, 1960. Photo by Ernest Withers and courtesy of the Withers Collection. © Withers Collection, Inc.

Page 19
Carl Braden. Photo by the Alabama Department of Public Safety and courtesy of the Alabama Department of Archives and History. © Alabama Department of Archives and History.

Page 19
Stokely Carmichael. Photo by the Alabama Department of Public Safety and courtesy of the Alabama Department of Archives and History. © Alabama Department of Archives and History.

Page 19
Anne Braden. Photo by the Alabama Department of Public Safety and courtesy of the Alabama Department of Archives and History. © Alabama Department of Archives and History.

Page 19
Martin Luther King Jr., Montgomery, Alabama, 1965. Photo by the Alabama Department of Public Safety and courtesy of the Alabama Department of Archives and History. © Alabama Department of Archives and History.

Page 19
"A Training School for Communists" propaganda photograph in newspaper: Martin Luther King Jr. attending a class at a training school for Communists, 1957. Photo courtesy of the Robert Langmuir African American Photograph Collection.

Page 20
Operation Tent City receives food from Philadelphia and other cities, Somerville, Tennessee, 1960. Photo by Ernest Withers and courtesy of the Withers Collection. © Withers Collection, Inc.

Page 20
Dick Gregory delivers food to farmers' families, Clarksdale, Mississippi, 1960. Photo by Ernest Withers and courtesy of the Withers Collection. © Withers Collection, Inc.

Page 21
"Tent City" family, created when black families were evicted from their homes for voting in 1960. They took up residence on the property of Shep Toles, Fayette County, Tennessee, 1960. Photo by Ernest Withers and courtesy of the Withers Collection. © Withers Collection, Inc.

Page 22
Young woman receives her voter registration card, Fayette County, Tennessee, 1960. Photo by Ernest Withers and courtesy of the Withers Collection. © Withers Collection, Inc.

Page 22
Willie Lee Wood Sr. demonstrating a voting machine for an audience in a small wooden church building in Prattville, Alabama, 1966. Photo by Jim Peppler and courtesy of the Alabama Department of Archives and History. © Alabama Department of Archives and History.

Page 23
105-year-old woman (former slave) registers to vote in Greenville, Mississippi, 1965. Photo by Bruce Hilton and courtesy of the Robert Langmuir African American Photograph Collection. © Bruce Hilton.

Freedom Rides, Jackson, MS, Birmingham, AL—1961

Page 25
National Guard members protecting the bus for the Freedom Riders leaving Montgomery, Alabama, for Jackson, Mississippi. Photo by Norman Dean and courtesy of the Alabama Department of Archives and History. © Alabama Department of Archives and History.

Page 26
Police officers arresting a Freedom Rider after the group's arrival at the Greyhound station in Birmingham, Alabama. Photo by Norman Dean and courtesy of the Alabama Department of Archives and History. © Alabama Department of Archives and History.

Page 27
Freedom Rider mug shot (Stokely Carmichael). Photo courtesy of the Mississippi Department of Archives and History.

Page 27
Freedom Rider mug shot (Patricia Bryant). Photo courtesy of the Mississippi Department of Archives and History.

Page 27
Freedom Rider mug shot (Catherine Burks). Photo courtesy of the Mississippi Department of Archives and History.

Page 27
Freedom Rider mug shot (James L. Bevel). Photo courtesy of the Mississippi Department of Archives and History.

James Meredith Integrates University of Mississippi, Oxford, MS—1962

Page 29
James Meredith being interviewed. Photo by Art Shay. © Art Shay Archives Project, LLC.

Page 30
Aerial shot of University of Mississippi, detailing National Guard presence. Photo by Art Shay. © Art Shay Archives Project, LLC.

Page 31
National Guard trucks near University of Mississippi. Photo by Art Shay. © Art Shay Archives Project, LLC.

Page 32
National Guard in Oxford, Mississippi. Photo by Art Shay. © Art Shay Archives Project, LLC.

Page 33
Effigy of James Meredith hanging. Photo by Art Shay. © Art Shay Archives Project, LLC.

March on Washington—1963

Page 35
Civil rights march on Washington, DC, view from Lincoln Memorial towards Washington Monument. Photo by Warren Leffler and courtesy of Wikimedia.

Page 36
African American protesters carry signs that call for equal rights, integrated schools, and an end to housing discrimination. Washington, DC.

Page 37
Civil rights leaders, including Martin Luther King Jr., are surrounded by crowds carrying signs, marching in DC. Photo by Warren Leffler and courtesy of Wikimedia.

Page 38
Attorney General Robert F. Kennedy speaking to a crowd of African Americans and whites through a megaphone outside the Justice Department. Photo by Warren Leffler and courtesy of Wikimedia.

Page 39
Civil rights leaders meet with John F. Kennedy. Photo by Warren Leffler and courtesy of Wikimedia.

Ku Klux Klan Rally in Salisbury, NC—1964

Page 41
KKK Rally, Hattiesburg, Mississippi, 1965. Photo by Wilfred Moncrief and courtesy of the Mississippi Department of Archives and History. © Wilfred Moncrief.

Page 42
Grand Dragon J. Robert Jones in Salisbury, North Carolina, standing with cigarette, 1964. Photo by Don Sturkey and courtesy of the Wilson Library. © Don Sturkey.

Page 43
Grand Dragon J. Robert Jones in Salisbury, North Carolina, standing with his wife in front of a car, 1964. Photo by Don Sturkey and courtesy of the Wilson Library. © Don Sturkey.

Page 44
Ku Klux Klan rally in Salisbury; Klan member in robes walks down the street with wife and daughter, 1964. Photo by Don Sturkey and courtesy of the Wilson Library. © Don Sturkey.

Page 44
Ku Klux Klan rally in Salisbury; marching Klan members stopped at crosswalk beneath a Western Union sign, 1964. Photo by Don Sturkey and courtesy of the Wilson Library. © Don Sturkey.

Page 45
Ku Klux Klan rally in Salisbury; Klan members drive past in convertible, 1964. Photo by Don Sturkey and courtesy of the Wilson Library. © Don Sturkey.

Page 45
Ku Klux Klan rally in Salisbury; three black women move past marching Klan members, 1964. Photo by Don Sturkey and courtesy of the Wilson Library. © Don Sturkey.

Page 46
Ku Klux Klan rally in Salisbury; speaker swipes his hand across the frame, 1964. Photo by Don Sturkey and courtesy of the Wilson Library. © Don Sturkey.

Page 47
Ku Klux Klan rally in Salisbury; small boy looks into the camera, 1964. Photo by Don Sturkey and courtesy of the Wilson Library. © Don Sturkey.

Page 47
Ku Klux Klan rally in Salisbury; speaker from behind the stage, 1964. Photo by Don Sturkey and courtesy of the Wilson Library. © Don Sturkey.

Page 48
Ku Klux Klan rally in Salisbury; torchlit procession of robed Klan members, 1964. Photo by Don Sturkey and courtesy of the Wilson Library. © Don Sturkey.

Page 48
Ku Klux Klan rally in Salisbury; Klan members circled about a blazing cross, 1964. Photo by Don Sturkey and courtesy of the Wilson Library. © Don Sturkey.

Page 49
Ku Klux Klan rally in Salisbury; Klan members circled about a blazing cross, 1964. Photo by Don Sturkey and courtesy of the Wilson Library. © Don Sturkey.

Page 50
Ku Klux Klan meeting in Morganton, North Carolina; Klan members lined up, presumably in prayer, before the event, 1965. Photo by Don Sturkey and courtesy of the Wilson Library. © Don Sturkey.

Page 51
Ku Klux Klan meeting in Morganton, North Carolina; Sybil Jones speaks, 1965. Photo by Don Sturkey and courtesy of the Wilson Library. © Don Sturkey.

Page 52
Ku Klux Klan marching in Pineville, North Carolina; marchers with American flag and Confederate battle flag held aloft, 1967. Photo by Don Sturkey and courtesy of the Wilson Library. © Don Sturkey.

Page 53
Ku Klux Klan marching in Pineville, North Carolina; car with sticker that reads, "Help Fight Communism and Integration: Join the KKK," 1967. Photo by Don Sturkey and courtesy of the Wilson Library. © Don Sturkey.

Page 54
Ku Klux Klansmen from the North Carolina Piedmont burning their membership cards on a cross, stapling cards to the cross, 1969. Photo by Don Sturkey and courtesy of the Wilson Library. © Don Sturkey.

Page 55
Ku Klux Klansmen from the North Carolina Piedmont burning their membership cards on a cross, erect cross with membership cards, 1969. Photo by Don Sturkey and courtesy of the Wilson Library. © Don Sturkey.

Page 56
Ku Klux Klansmen from the North Carolina Piedmont burning their membership cards on a cross, cross ablaze, 1969. Photo by Don Sturkey and courtesy of the Wilson Library. © Don Sturkey.

Page 57
Ku Klux Klansmen from the North Carolina Piedmont burning their membership cards on a cross, painted car with the words "America: Love It or Leave It," 1969. Photo by Don Sturkey and courtesy of the Wilson Library. © Don Sturkey.

Page 58
1960s KKK activity in North Carolina; robed members with torches circle. Photo by Don Sturkey and courtesy of the Wilson Library. © Don Sturkey.

Page 59
1960s KKK activity in North Carolina; speaker at rally. Photo by Don Sturkey and courtesy of the Wilson Library. © Don Sturkey.

Selma to Montgomery March—1965

Page 61
Carrying satchels and suitcases, six hundred marchers make their way over the Edmund Pettus Bridge. Photo by Spider Martin and courtesy of the Briscoe Center. © Spider Martin.

Page 62
African American children with an American flag, probably during the Selma to Montgomery March. Photo courtesy of the Alabama Department of Archives and History. © Alabama Department of Archives and History.

Page 62
African American women, children, and an older man waving to Selma to Montgomery marchers from the sidewalk. Photo courtesy of the Alabama Department of Archives and History. © Alabama Department of Archives and History.

Page 63
Marchers resting during the march from Selma to Montgomery, Alabama. Photo by Spider Martin and courtesy of the Briscoe Center. © Spider Martin.

Page 63
A marcher's blistered feet bear witness to the grueling nature of the fifty-four-mile march from Selma to Montgomery. Photo by Spider Martin and courtesy of the Briscoe Center. © Spider Martin.

Page 64
Unidentified man on the Selma to Montgomery March for voting rights wears a jacket painted with the words "Alabama God-Damn." Photo by Spider Martin and courtesy of the Briscoe Center. © Spider Martin.

Page 65
White hecklers confront civil rights marchers from behind a Confederate flag. Photo by Spider Martin and courtesy of the Briscoe Center. © Spider Martin.

Page 66
Counter-demonstrators in Montgomery, Alabama. Photo by Spider Martin and courtesy of the Briscoe Center. © Spider Martin.

Page 66
By Alabama state capitol, counter-demonstrators carry signs protesting the voting rights marchers led by Martin Luther King Jr. Photo by Spider Martin and courtesy of the Briscoe Center. © Spider Martin.

Page 67
Martin Luther King Jr. speaking to an audience at Brown Chapel in Selma, Alabama, 1966. Photo by Jim Peppler and courtesy of the Alabama Department of Archives and History. © Alabama Department of Archives and History.

Page 67
Rev. Andrew Young leads march organizers in prayer across the street from Brown Chapel AME Church in Selma. Photo by Spider Martin and courtesy of the Briscoe Center. © Spider Martin.

Page 68
The March for Voting Rights from Selma to Montgomery makes its way through Lowndes County under the protection of US Army. Photo by Spider Martin and courtesy of the Briscoe Center. © Spider Martin.

Page 68
Marchers cross the Edmund Pettus Bridge and return to Selma on Turnaround Tuesday. Photo by Spider Martin and courtesy of the Briscoe Center. © Spider Martin.

Pages 69 and 134–35
Participants of the March for Voting Rights third march making its way over the Edmund Pettus Bridge. Photo by Spider Martin and courtesy of the Briscoe Center. © Spider Martin.

Page 70
Rev. Hosea Williams, John Lewis, and others in the March for Voting Rights to Montgomery confronted by Alabama state troopers. Photo by Spider Martin and courtesy of the Briscoe Center. © Spider Martin.

Page 70
Alabama state trooper beating John Lewis as other marchers run back towards the Edmund Pettus Bridge. Photo by Spider Martin and courtesy of the Briscoe Center. © Spider Martin.

Page 72
Looking down and from behind at marchers as they wind around a traffic island and up the road with the state capitol in the distance. Photo courtesy of the Mississippi Department of Archives and History.

Page 72
View looking down upon the Selma march preceded by a truck of press men as they march toward the state capitol in Montgomery. Photo courtesy of the Mississippi Department of Archives and History.

Page 73
View looking down upon the civil rights leaders at the front of the Selma march as they march toward the state capitol in Montgomery. Photo courtesy of the Mississippi Department of Archives and History.

Page 73
Closeup view looking down on Selma marchers as they march toward the state capitol in Montgomery. Photo courtesy of the Mississippi Department of Archives and History.

Page 74
Selma's Wilson Baker receives a telegram reacting to news of the Bloody Sunday events. Photo by Spider Martin and courtesy of the Briscoe Center. © Spider Martin.

Page 74
Flyers list civil rights activists injured by Alabama state troopers on "Bloody Sunday." Photo by Spider Martin and courtesy of the Briscoe Center. © Spider Martin.

Page 75
A voting rights demonstrator rests during the march to Montgomery. Photo by Spider Martin and courtesy of the Briscoe Center. © Spider Martin.

James Meredith March Against Fear, Jackson, MS—1966

Page 77
Participants in the "March Against Fear" begun by James Meredith, walking down North State Street in Jackson, Mississippi. Photo by Jim Peppler and courtesy of the Alabama Department of Archives and History. © Alabama Department of Archives and History.

Page 78
Dick Gregory on porch of James Meredith's family home during the March Against Fear, Kosciusko, Mississippi. Photo by Ernest Withers and courtesy of the Withers Collection. © Withers Collection, Inc.

Page 79
Participants in the "March Against Fear" begun by James Meredith, walking down the street of a neighborhood, Mississippi. Photo by Jim Peppler and courtesy of the Alabama Department of Archives and History. © Alabama Department of Archives and History.

Page 80
Four white men sitting on the platform in front of a billboard, observing the "March Against Fear" through Mississippi. Photo by Jim Peppler and courtesy of the Alabama Department of Archives and History. © Alabama Department of Archives and History.

Page 80
White boys on the side of a street during the "March Against Fear" begun by James Meredith. Photo by Jim Peppler and courtesy of the Alabama Department of Archives and History. © Alabama Department of Archives and History.

Page 81
March Against Fear, Coldwater, Mississippi. Photo by Ernest Withers and courtesy of the Withers Collection. © Withers Collection, Inc.

Page 82
Dr. Martin Luther King Jr. resting reading the *Memphis Press-Scimitar* in the Lorraine Motel following the March Against Fear, Memphis, Tennessee. Photo by Ernest Withers and courtesy of the Withers Collection. © Ernest Withers Collection, Inc.

Page 83
James Meredith returns home after being shot, Kosciusko, Mississippi, 1968. Photo by Ernest Withers and courtesy of the Withers Collection. © Withers Collection, Inc.

Mule Train—Poor People's March on Washington, Marks, MS—1968

Page 85
Mule train leaves for Washington, Poor People's March, Marks, Mississippi. Photo by Ernest Withers and courtesy of the Withers Collection. © Withers Collection, Inc.

Page 86
Mule Train, Marks, Mississippi. Photo by Ernest Withers and courtesy of the Withers Collection. © Withers Collection, Inc.

Page 86
Mule Train—Poor People's March, Marks, Mississippi. Photo by Ernest Withers and courtesy of the Withers Collection. © Withers Collection, Inc.

Page 87
Mule Train—Poor People's March, Marks, Mississippi. Photo by Ernest Withers and courtesy of the Withers Collection. © Withers Collection, Inc.

Page 88
Poor Peoples Campaign, Marks, Mississippi, 1968. SCLC staff training for march to DC. Photo by Ernest Withers and courtesy of the Withers Collection. © Withers Collection, Inc.

Page 89
Woman and children inside a plywood shack in Resurrection City during the Poor People's Campaign, Washington, DC. Photo by Jim Peppler and courtesy of the Alabama Department of Archives and History. © Alabama Department of Archives and History.

Sanitation Workers Strike, Memphis, TN—1968

Page 91
Children pose in front of garbage during sanitation workers' strike, Memphis, Tennessee, March 1968. Signs read, "Garbage for Sale" and "Justice." Photo by Ernest Withers and courtesy of the Withers Collection. © Withers Collection, Inc.

Page 92
Downtown Main Street, Memphis, Tennessee, March 1968, during sanitation workers' strike. Sign reads, "We are together." Photo by Ernest Withers and courtesy of the Withers Collection. © Withers Collection, Inc.

Page 93
Sanitation workers' march is stopped on Main Street, Memphis, Tennessee. Photo by Ernest Withers and courtesy of the Withers Collection. © Withers Collection, Inc.

Martin Luther King Jr. Assassination, Memphis, TN—1968

Page 95
View of the Lorraine Motel from James Earl Ray's vantage in boarding house. Photo by Art Shay. © Art Shay Archives Project, LLC.

Page 96
Boarding house bathroom window from which James Earl Ray shot and killed Dr. King. 422 South Main Street, Memphis. Photo by Ernest Withers and courtesy of the Withers Collection. © Withers Collection, Inc.

Page 96
Martin Luther King's blood on balcony of Lorraine Motel. Photo by Ernest Withers and courtesy of the Withers Collection. © Withers Collection, Inc.

Page 97
Briefcase of Dr King, room 306, Lorraine Motel, following his assassination. Photo by Ernest Withers and courtesy of the Withers Collection. © Withers Collection, Inc.

Page 98
Mourners look on at King's body in R. S. Lewis Funeral Home. Photo by Art Shay. © Art Shay Archives Project, LLC.

Page 99
Mourner looks on at King's body in R. S. Lewis Funeral Home. Photo by Art Shay. © Art Shay Archives Project, LLC.

Page 99
Dr. King's coffin loaded onto a plane to Atlanta. Photo by Arty Shay. © Art Shay Archives Project, LLC.

Page 100
On the balcony of the Lorraine Motel following the assassination of MLK. Photo by Ernest Withers and courtesy of the Withers Collection. © Withers Collection, Inc.

Page 101
Wreaths and flowers left as memorials to Dr. King at the Lorraine Motel. Photo by Art Shay. © Art Shay Archives Project, LLC.

Page 102
Coretta Scott King at Mason Temple, speaking at same podium from which Dr. King made his last speech, Memphis, Tennessee Photo by Ernest Withers and courtesy of the Withers Collection. © Withers Collection, Inc.

Page 102
Coretta Scott King and Martin Luther King Sr. in Dr. King's funeral procession, Atlanta, Georgia, April 1968. Young boy is MLK III, with Bernard Lee behind Coretta Scott King. Photo by Ernest Withers and courtesy of the Withers Collection. © Withers Collection, Inc.

Page 103
Coretta Scott King and Rosa Parks march following King's assassination, Memphis, Tennessee. Photo by Art Shay. © Art Shay Archives Project, LLC.

Page 104
Crowd outside Lorraine Motel after the assassination of Dr. King. Photo by Ernest Withers and courtesy of the Withers Collection. © Withers Collection, Inc.

Page 105
Marchers at entrance of the Lorraine Motel after the assassination of Dr. King. Photo by Ernest Withers and courtesy of the Withers Collection. © Withers Collection, Inc.

Page 106
Mourners following Dr. King's assassination, a single sign held aloft, Memphis, Tennessee. Photo by Art Shay. © Art Shay Archives Project, LLC.

Pages 106 and 132–33
Mourning crowd following Dr. King's assassination, Memphis, Tennessee. Photo by Art Shay. © Art Shay Archives Project, LLC.

Page 107
Mourners and demonstrators, carrying signs, line up in the street, Memphis, Tennessee. Photo by Art Shay. © Art Shay Archives Project, LLC.

Page 108
National Guard at Main and Linden Street after the assassination of Dr. King, Memphis, Tennessee. Photo by Ernest Withers and courtesy of the Withers Collection. © Withers Collection, Inc.

Page 109
Searching for Dr. King's killer, Memphis, Tennessee. Photo by Art Shay. © Art Shay Archives Project, LLC.

Page 110
Photographers over Dr. King's casket, Memphis, Tennessee. Photo by Ernest Withers and courtesy of the Withers Collection. © Withers Collection, Inc.

Page 110
Dr. Martin Luther King Jr. in casket at R. S. Lewis funeral home. Journalist is Maurice Sorrell, photographer for *Jet*, Memphis, Tennessee. Photo by Ernest Withers and courtesy of the Withers Collection. © Withers Collection, Inc.

Page 111
Son of Rev. Ralph Abernathy rides on the back of press truck after assassination of Dr. King, Memphis, Tennessee. Nick Taylor with wire, Memphis

talk show. Photo by Ernest Withers and courtesy of the Withers Collection. © Withers Collection, Inc.

Jackson State University—1970

Page 113
Gibbs Green student hearings, Masonic Temple, Jackson, Mississippi, 1970. Photo by Doris Derby. © Doris Derby.

Page 114
James Green's funeral procession, Lynch Street, Jackson, Mississippi, 1970. Photo by Doris Derby. © Doris Derby.

Page 114
Dignitaries at James Green's funeral, Masonic Temple, Jackson, Mississippi, 1970. Photo by Doris Derby. © Doris Derby.

Page 115
James Green's funeral procession, Lynch Street, Jackson, Mississippi, 1970. Photo by Doris Derby. © Doris Derby.

Page 116
Alexander Hall protestors of Gibbs Green murder, Jackson State University, Jackson, Mississippi, 1970. Photo by Doris Derby. © Doris Derby.

Page 116
Gibbs Green murder hearings, JSU student and Attorney Constance Slaughter Harvey, Jackson, Mississippi, 1970. Photo by Doris Derby. © Doris Derby.

Page 117
James Green's funeral procession onlookers, Lynch Street, Jackson, Mississippi, 1970. Photo by Doris Derby. © Doris Derby.

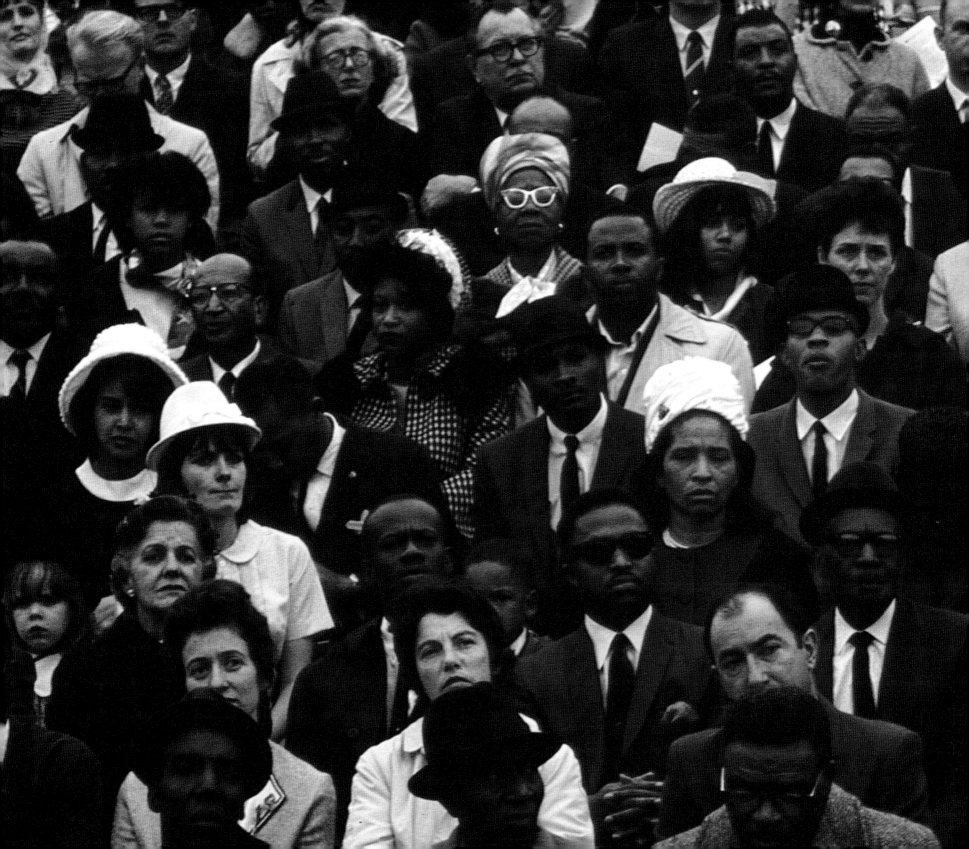

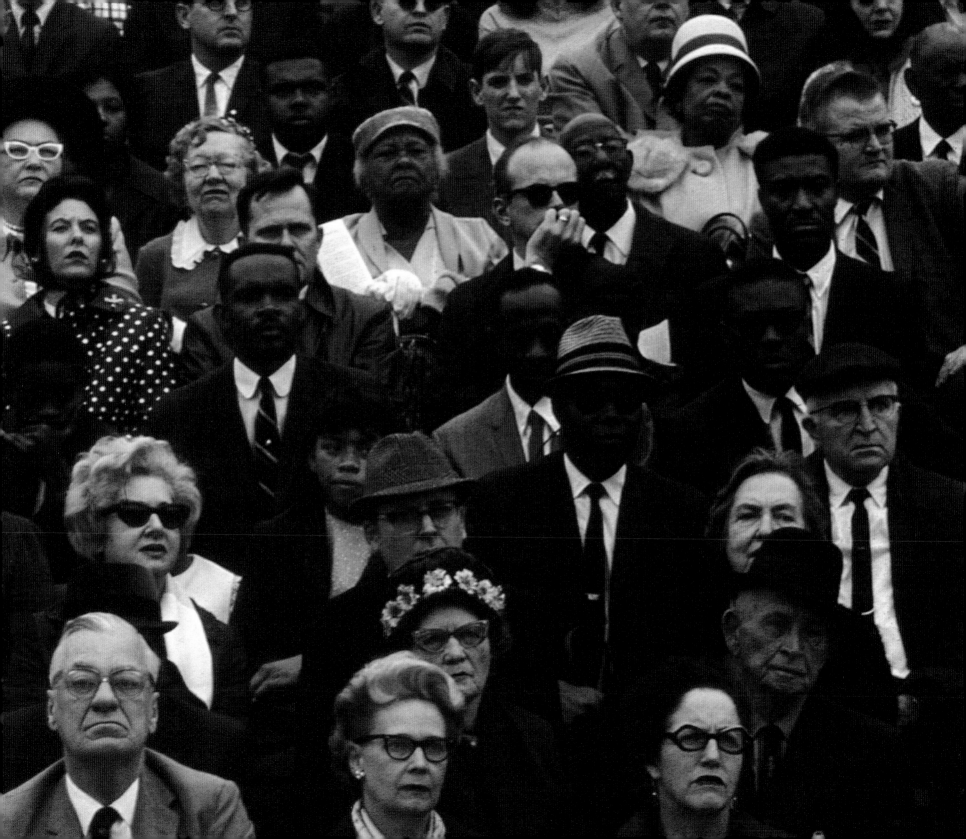

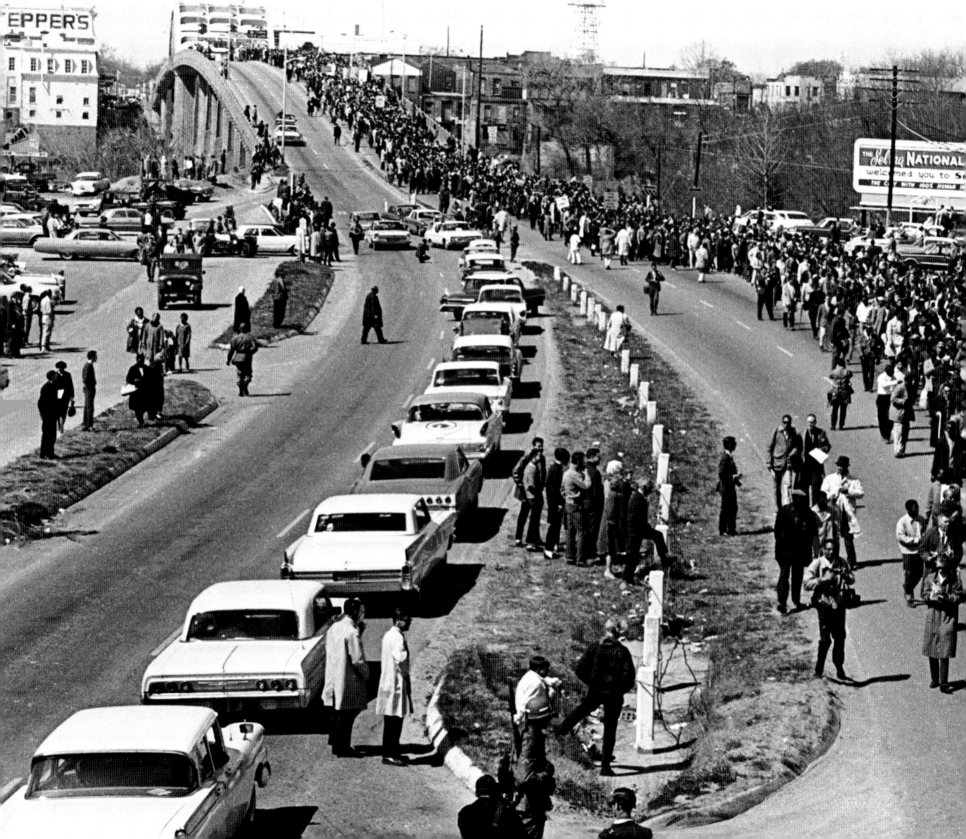

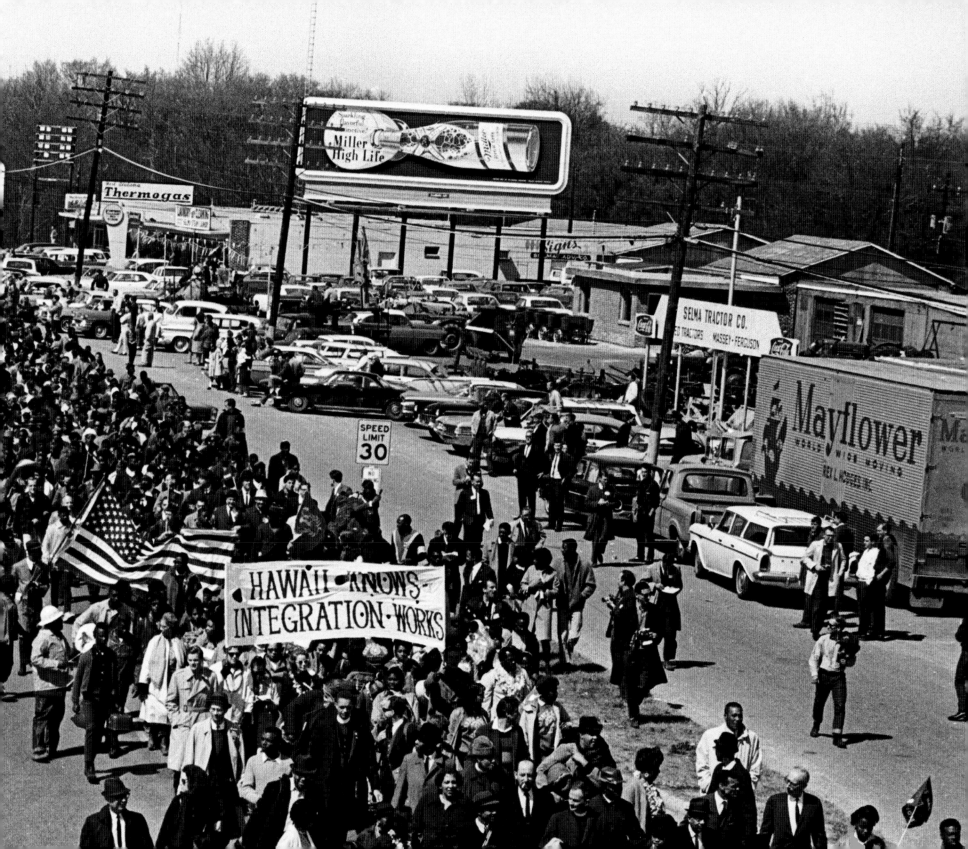

ABOUT THE AUTHORS

Credit: Smithsonian Institution

Photo by Marcie Cohen Ferris

LONNIE G. BUNCH III was born in Newark, New Jersey, in 1952. He grew up in Belleville, New Jersey, where his family were the only African Americans in their neighborhood. His grandfather, a former sharecropper, was one of the first black dentists in the region, and Bunch's father and mother were schoolteachers.

Bunch attended Howard University and transferred to American University, where he earned his PhD in history in 1979. Bunch is the fourteenth Secretary of the Smithsonian Institution, the first African American and first historian to serve in that position. He served as the founding director of the Smithsonian's National Museum of African American History and Culture from 2005 to 2019.

He served on the Commission for the Preservation of the White House during the George W. Bush administration and was reappointed to the commission by President Barack Obama in 2010.

WILLIAM R. FERRIS is the Joel R. Williamson Eminent Professor of History Emeritus at the University of North Carolina at Chapel Hill and the senior associate director emeritus of its Center for the Study of the American South. The former chairman of the National Endowment for the Humanities (1997–2001), Ferris coedited the *Encyclopedia of Southern Culture*. His other books include *Mule Trader: Ray Lum's Tales of Horses, Mules and Men*; *Local Color*; *Images of the South: Visits with Eudora Welty and Walker Evans*;, *Blues from the Delta*; *Give My Poor Heart Ease: Voices of the Mississippi Blues*; *The Storied South: Voices of Writers and Artists*; and *The South in Color: A Visual Journal*.

Ferris's most recent work, *Voices of Mississippi*, received two Grammy Awards for Best Historical Album and Best Liner Notes in 2019. The collection represents the life's work of Ferris as a folklorist whose photography, sound recordings, and documentary films reflect his enduring commitment to the study of the American South.